Painting Great Pictures

from Photographs

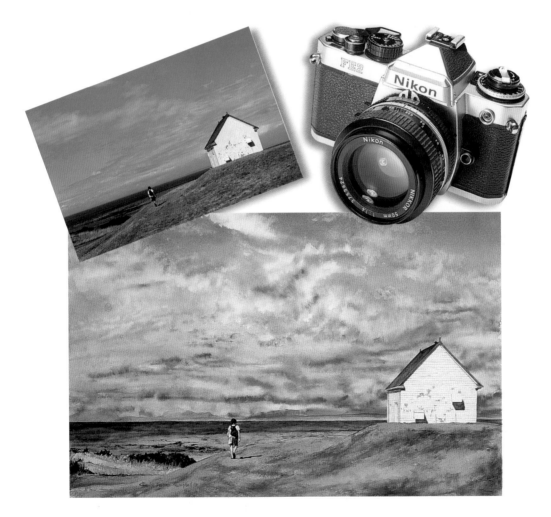

Painting Great Pictures

from Photographs

GAIN NEW VISUAL REFERENCES AND
CREATIVE POSSIBILITIES

HAZEL HARRISON

David & Charles

A DAVID & CHARLES BOOK

First published in the UK in 1999

Copyright © 1999 Quarto Publishing plc.

A catalogue record for this book is available
from the British Library.

ISBN 0 7153 1004 6

QUAR.SHPT

This book was conceived, designed, and produced by
Quarto Publishing plc
The Old Brewery
6 Blundell Street
London N7 9BH

Senior Editor *Anna Watson*
Art Editor *Sally Bond*
Assistant Art Director *Penny Cobb*
Copy Editor *Clare Haworth Maden*
Designer *Liz Brown*
Photographers *Colin Bowling, Les Weis,*
Ian Howes
Illustrators *Annie Penney, Margaret Glass*
Picture researcher *Frank Crawford*
Indexer *Susan Cawthorne*
Art director *Moira Clinch*
Publisher *Piers Spence*

Typeset in Great Britain by Central
Southern Typesetters, Eastbourne, UK
Manufactured in China by Regent
Publishing Services Ltd.
Printed in China by
Leefung-Asco Printers Ltd.

For David & Charles
Brunel House Newton Abbot Devon

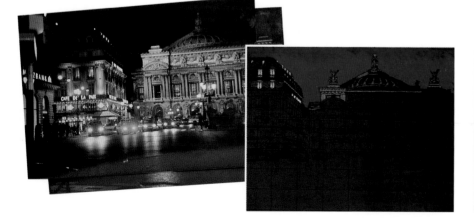

Contents

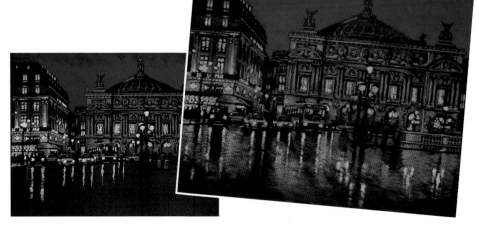

Introduction

If you are one of the many amateur painters who work from photographs but feel a little ashamed – as though you were cheating in some way – you need worry no longer. Although there is a lingering prejudice against using photographic reference, to many professional artists the camera is essential. They regard it as the first stage in planning and gathering information, and as the paintings and demonstrations in this book show, it gives them the means to produce work that is every bit as individual and exciting as anything done direct from life.

The advantages are obvious – a camera offers you a vast choice of subject matter, allowing you to capture moving objects and fleeting effects of light in a matter of seconds, and to record anything that appeals to you while travelling or on holiday. But it is vital to remember that you are translating one kind of image into another. Put your personal stamp on it by the way you use your colours and your medium.

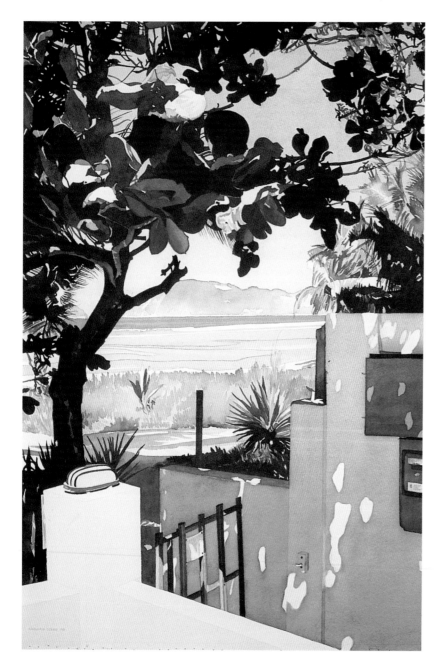

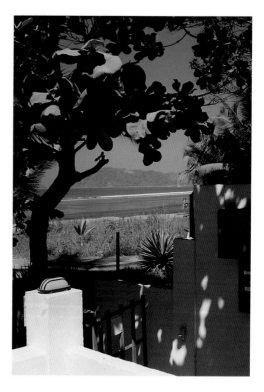

***Club del Mar*, watercolour**
Linda Kooluris Dobbs
Left The artist has kept the composition of the painting almost identical to her photo, but has lightened the colours to compensate for the limitations of capturing light on film.

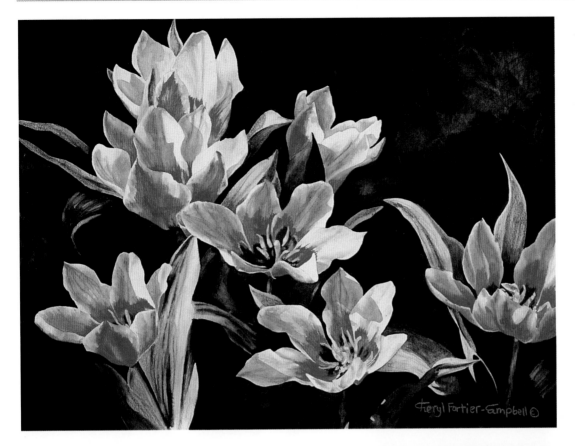

Dancing, watercolour
**Cheryl Fortier-
 Campbell**
Left There is no need
to be tied to the
images you create
with your camera –
here the artist
decided that using
only a section of the
photo gave her
painting a more
dynamic composition.

SKETCHING WITH THE CAMERA

You must learn to use the camera as a tool, just like your paintbrushes and colours, and to do this you must recognize both your both your own interests and the camera's limitations. *Using Your Camera as a Sketchbook* provides valuable advice on this topic, and helps you to get the best out of your 'sketchbook'. For example, if you are not sure how a composition will work out, give yourself more choice by taking several photos. If you want to make a feature of shadow or sky colours, take separate shots of these, as they don't always come out well. Keep a reference file of photos of figures or other objects that you might include in a landscape or urban scene.

MAKING THE PAINTINGS

You will have made some decisions through the camera's viewfinder, but there are equally important ones to be made once you start to paint. *Preparing to Paint* focuses on the planning stage in which you edit your photos and decide how to treat the subject, from choosing the format, composition, and medium to making the underdrawing. This practical advice is followed by *From Photos to Paintings* – a series of fascinating step-by-step demonstrations in which you can trace an artist's progress right through from taking the photographs to completing the painting. These are interspersed with special gallery

features, showing finished paintings in a wide variety of styles, each one accompanied by the photographic reference from which the artist has worked. As you will see from these inspirational examples, good paintings can be made from photographs but seldom by direct copying. Use the camera only as a tool, and never allow yourself to lose sight of your personal artistic vision.

Choosing a camera

For the artist, the camera is a tool of the trade, and like all tools, must be fit for its purpose. This chapter presents some ideas about the best type of camera to choose, and helps first-time buyers by explaining the technical terms used in the photographic trade. Even the more experienced camera-users may find some interesting new information, and may be tempted to buy a second camera – as all gardeners and carpenters know, one tool can't do all the jobs.

Types of *camera*

- **Compact and SLR cameras**
- **Deciding what you need**
- **Innovations and options**

A visit to a camera store will present you with a large range of cameras, but there are only two main types. With a 'point-and-shoot' compact camera, you compose your image through a viewfinder that is separate from the lens. With a single-lens reflex (SLR) camera, the image seen through the lens is reflected into the viewfinder by a mirror so that you see the exact image you will get on film. Although compact cameras are often known as automatic, the term can cause confusion because most modern SLR cameras are also automatic, both in focusing and exposure times.

PROS AND CONS

Compact cameras are adequate for many purposes and, being small and light, are ideal for landscape photographs taken when out walking, but they do have limitations. Because they make all the decisions about shutter speeds and aperture for you, you don't have much control over the process. You can't decide, for example, that a certain subject might benefit from a longer exposure, or that throwing the background out of focus by reducing the depth of field (see page 28) might be effective. In addition, because you are not seeing exactly what the lens sees, you can't be quite sure of getting everything that you want into your picture, especially if your subject is close. We have all seen snapshots of people with 'chopped-off' heads, and although cameras are becoming more and more sophisticated this can still be a problem.

Above A compact camera is portable and easy to use, with a built-in lens and flash.

Right SLR cameras give you more control over your images, but are more complex to use.

With an SLR on the other hand, what you get is what you see, and this makes composing the image easier. Most of these cameras have an auto mode, which sets the correct shutter speed and aperture for the prevalent lighting conditions, and some also have automatic focusing. In most SLR cameras, however, you can manipulate the automatic functions to serve your own requirements: the simplest way of doing this is to turn the

See also: Getting it in focus (page 28)
Low-light photographs (page 34)
Light & dark (page 36)

aperture setting round and watch in the viewfinder as the exposure time changes. This allows you to aim for the length of exposure you want (see pages 14–15). You can also override the automatic metering to compensate for shooting against the light. If you are thinking of buying an SLR, make sure that there is a manual override facility.

The main disadvantage of SLR cameras is that they are larger and heavier than compacts. If your budget can stretch to it, it is worth considering buying two cameras: a compact for outdoor shots and an SLR for low-light photography, indoor work, and close-ups, such as shots of individual flowers. Cameras are no longer the expensive items that they once were, and if photographs are to be your main source material for painting, purchasing both is worth the initial outlay.

Single Use Cameras

Single use or disposable cameras are widely available and can be successfully used to provide source material for your paintings. You can buy types with different film speeds, or automatic flash, or even for use underwater. They have only a fixed focal length, so you cannot use them for close-up shots, but they are adequate for landscapes and medium distance shots.

A shot from an underwater disposable camera

Advanced Photo System

This is a recent development in photography, which includes some totally new facilities. The Advanced Photo System (APS) capability gives you the choice of three image formats, so that you can choose the best one for the subject simply by pressing a button. APS cameras are made by several manufacturers and vary in price according to the other facilities they provide; in general they compare favourably with zoom-lens automatics in terms of price. Some are mini-SLRs, others are automatic, and most incorporate zoom lenses, autofocusing, etc.

The other feature of APS is index printing. The prints are returned with a sheet showing a thumbnail image of each shot, so ordering enlargements or new prints is very easy. There are no negatives; the film remains inside a cartridge, keeping it free from dirt and scratches. The only disadvantage is that these film cartridges can at present only be obtained from photographic stores, and the prints are relatively expensive. It is safe to assume that the laws of the market-place will push prices down.

Lenses

- **Lenses in compact and SLR cameras**
- **The meaning of lens length**
- **Zoom and macro facilities**

In the past, one of the main reasons for choosing an SLR camera rather than a compact was that it allowed you to use a variety of lenses. The lens of a compact is built into the camera, but with SLRs it is detachable, so you can replace the standard lens with a wide-angle or telephoto lens. Photographers who record wildlife – and, of course, the paparazzi – use interchangeable lenses, especially telephotos, which magnify the subject to the extent that photographs can be taken without the photographer being noticed, but these are much too heavy and cumbersome for the purposes of the artist who is making a photographic sketchbook. A much more useful lens is the zoom, which allows you to vary the focal length without changing the lens, and most cameras, both SLR and compact, are now sold with zoom lenses instead of the once-standard 50mm lens.

Left Short zoom lens wide-angle 35–85mm

Left Long zoom lens 70–200mm

Above Standard 50mm lens

Left 105mm macro lens

Above A compact camera with a built in 35–105mm zoom lens.

See also: **Choosing the focal length (page 26)**
Low-light photographs (page 34)
Photographs from television (page 44)

HOW LENSES ARE DESCRIBED

If you buy a separate lens for an SLR, it will be described by its focal length. This does not mean much to the inexperienced photographer, so the following rough guide may be useful.

A wide-angle lens, which takes in more of the view than you can actually see without moving your eyes, ranges from 28 to 35mm. A standard lens, which is closest to what you can actually see with the naked eye, is 50mm, and a long lens, which brings your subject closer, can range from 50mm upward, although the zoom effect isn't really noticeable until you reach 75mm. Zoom-lens compact cameras and lenses sold as part of an SLR kit usually offer focal lengths ranging from 35 to 90 or 105mm, and also have a macro facility, allowing you to shoot subjects in close-up. Separate telephoto lenses for SLR cameras are available; 150 or 200mm can be useful, but remember that they are relatively heavy and so you may want to support the camera on a tripod in order to avoid camera shake.

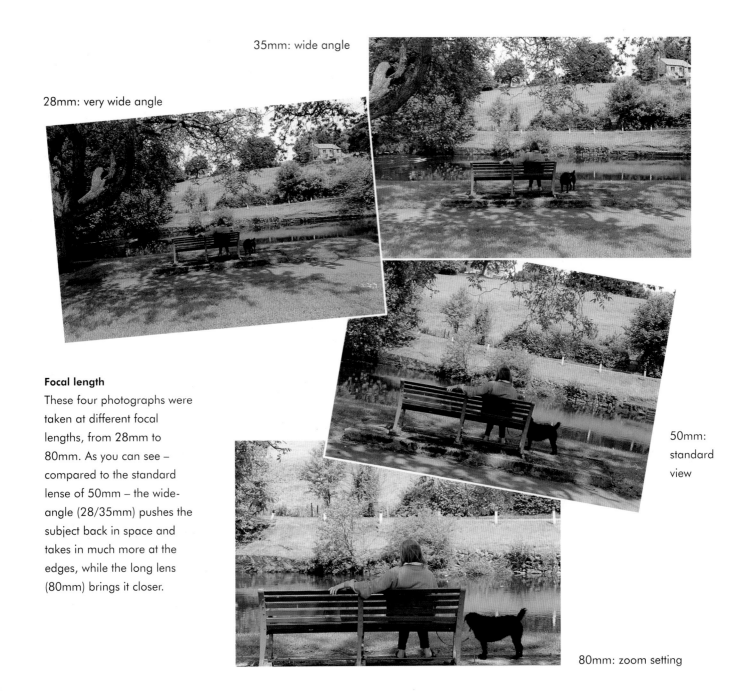

35mm: wide angle

28mm: very wide angle

50mm: standard view

80mm: zoom setting

Focal length
These four photographs were taken at different focal lengths, from 28mm to 80mm. As you can see – compared to the standard lense of 50mm – the wide-angle (28/35mm) pushes the subject back in space and takes in much more at the edges, while the long lens (80mm) brings it closer.

Exposing *the film*

- **Shutter speed and aperture**
- **Exposure compensation**
- **How to choose your film speed**

At its most basic level, photography is the process of exposing film to light, in most cases for only a fraction of a second. The amount of light that is let in is controlled by two things: the shutter speed (length of exposure) and the size of the aperture (or f-stop). With a fully automatic camera you don't have any control over the aperture size and shutter speed but you will take better photographs if you understand the principal of exposure, because in

some circumstances you may need deliberately to under- or overexpose your subject (see page 36). Certain subjects, such as snow, white buildings or light-reflecting water, produce inflated light readings and it is therefore often wise to underexpose slightly. For a face or figure set against a bright sky you will need to overexpose or the subject will be very dark and any detail will be lost. Most good automatic cameras have an exposure-compensation button that allows you to perform such regulation. With a manual camera, you can simply increase or decrease the shutter speed or set a larger or smaller aperture.

FILM SPEED

All film, whether colour-print film, colour-slide film or black and white, is available in a variety of speeds denoted by an ISO or ASA number (ISO for International Standards Association, ASA stands for American Standards Association, but the numbers are the same). The higher the ISO number, the faster the film will react to the light, so needing less exposure time.

If possible, tailor the film that you use to the prevailing light: for example, if you are going on holiday to the Mediterranean, Florida or perhaps India or Africa, the light will be very bright, so you could use a 100 or (at most) 200 ISO, while for northern climes, overcast conditions, indoor and low-light photography, 400 ISO would be the best choice.

The faster films produce a slightly grainier print than the slow ones but this is not a significant factor unless you intend to enlarge the image considerably – the grain won't show on a normal-sized print.

Colour Casts

Sometimes you may find that your prints come back with an all-over cast of colour. This most commonly happens when you don't use a flash with indoor lighting, which produces an orange cast. Strong artificial lighting, such as that used on buildings at night, will produce a green cast on normal films. If you are doing a lot of indoor photography with artificial light (rather than natural light coming in through a window) you can buy special slide film that compensates for this.

The green cast on the building is caused by exposing normal daylight film to artificial lighting

See also: Indoor subjects (page 40)
Light & dark (page 36)

Exposure faults
The photo at far left was taken in very bright sunlight, and is slightly overexposed. In the other, only the view through the window is correctly exposed, because the film can't cope with extremes of light and dark. For painting reference, a separate photo of the figure and windows, with exposure compensation or a separate meter reading, would be essential.

Film Speeds

FILM SPEED	CONDITIONS
100 ISO	Ideal for sunny conditions; fine grain and vivid colours
200 ISO	A good catch-all speed for variable weather conditions; fine grain
400 ISO	Suitable for overcast weather and for low-light or indoor work with a tripod; noticeable grain
800 ISO	Tends to be more grainy; very useful for low-light work

Right: 100 ISO film is perfect for brightly sunlit conditions

Using your camera
as a sketchbook

This chapter concentrates on helping you to obtain the best possible reference shots for your paintings, first by deciding on your pictorial interests, and second by understanding the limitations of the camera. Poor photographs are a source of frustration to the artist, but they are usually the result of errors that can be avoided when you have gained knowledge and expertise.

Looking & *thinking*

- **Planning the painting**
- **Analyzing the subject**
- **Making backup notes**

There is a considerable difference between taking photographs for their own sake and taking them as painting references. A superb photograph is not always the best starting point for a painting, partly because it will tempt you to copy it exactly and partly because it may not provide the painterly information that you need.

When you start to take sketchbook photos, always try to think in terms of the eventual painting and regard the photographs as the first stage in planning it. Look at the subject with an analytical eye and decide what interests you the most about it. In a landscape, for instance, is there a particular feature that especially excites you, such as a tree or an old barn? Is colour your main concern, or do you instead want to convey a sense of space or atmosphere? Don't just take photos randomly in the hope that the prints will provide you with inspiration – the inspiration must be there first.

ADDITIONAL INFORMATION

Sadly, you will sometimes find that the photographs that you took have failed to capture your initial excitement and that the colours are not as you remembered them. The camera is not perfect, and it can sometimes deal badly with colour, especially when it comes to skies, shadows (see page 36) and the subtle nuances that create space and depth in a landscape. It is therefore a good idea to make notes about the colours in your subject at the same time as you are photographing it. You can make either written or visual notes in a small notebook or sketchbook, or you could combine the two. Some artists compose paintings from no more than a rough pencil outline and small swatches of colour, backed up by written descriptions, and since you will have the photos as well, you won't be short of information.

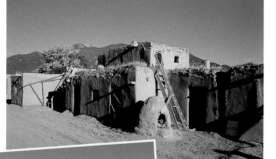

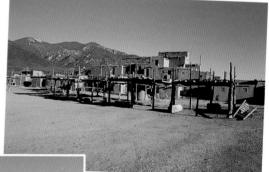

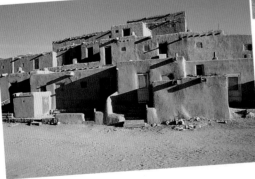

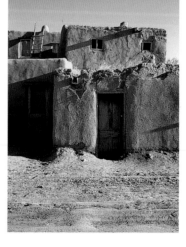

Exploring the subject
These are four from a series of photos, in which the artist made a comprehensive record of colours, structures, textures and shadow effects.

See also: Viewpoint (page 20)
Composition (page 22)
Light & dark (page 36)

Making extra notes

If you were painting on the spot, you would consider your composition very carefully. Sketching can help you decide which angles and details to photograph.

A quick tonal sketch of the balance of light and shade is useful, as your camera may not record it accurately.

Colour swatches give more fine nuances than your photo prints.

Composing through the lens

The artist chose just the right moment to take her photograph, when the walker provided a balance for the white building, as well as breaking the horizontal line of the sea.

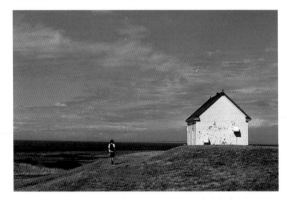

Passages, watercolour, Cheryl Fortier-Campbell

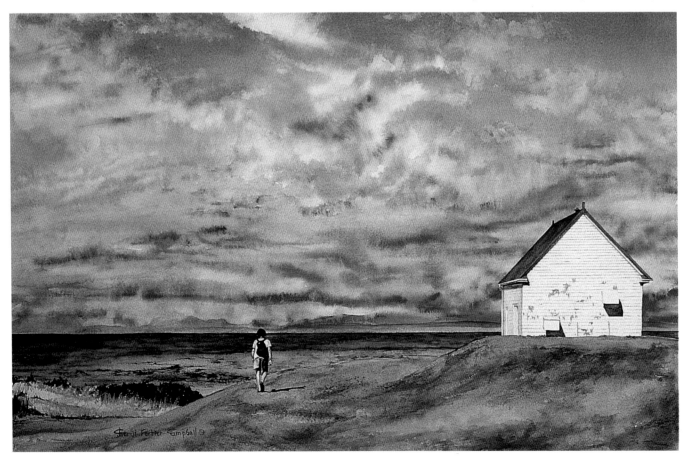

Viewpoint

- **Emphasizing drama**
- **Creating patterns**
- **Ensuring that your photos make sense**

When you are painting outdoors your viewpoint is often limited: there may be only one convenient place in which to sit or stand, or perhaps none at all – you may like the view from the middle of a road, for example. The great advantage of the camera is that it gives you a wide choice of viewpoints: you can move freely from side to side and you can sometimes climb onto a wall for a high, downward-looking view, or squat down for a low, upward-looking one.

Most people automatically take photos from an eye-level position, simply because they are walking about with a camera, but this does not always provide the most exciting image. The height of tall buildings, cliffs or rock formations, can be emphasized dramatically by a low viewpoint, while a high viewpoint for such subjects as cityscapes, gardens or 'found' still lifes reveals patterns that would not be present in an eye-level view.

FROM SIDE TO SIDE

Even taking a few paces from one side to the other can make a considerable difference to an image. A frontal view of a building can be effective if your main interest is architectural details – you might want to home in on a doorway, for instance, or a window with window-boxes – but the photograph will lack depth and will give no sense of the building's overall structure. A corner, on the other hand, makes the building look solid and may also help the composition of the painting, providing diagonal lines of perspective as well as the verticals and horizontals.

By moving your position slightly you can also avoid obscuring one feature with another – a common mistake. If your subject is a group of trees or people, take care that they do not overlap too much, or in an awkward way, or you may find when you come to paint that you can't 'read' the photograph and don't understand the spatial relationships within it.

Allison Bathing, **watercolour**
Judith Rein

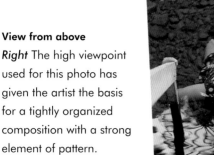

View from above
Right The high viewpoint used for this photo has given the artist the basis for a tightly organized composition with a strong element of pattern.

See also: Composition (page 22)

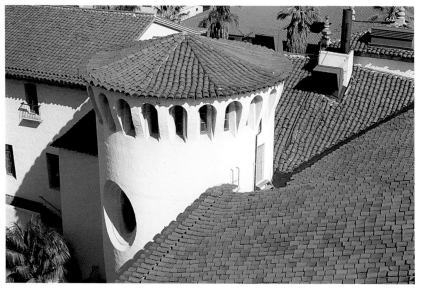

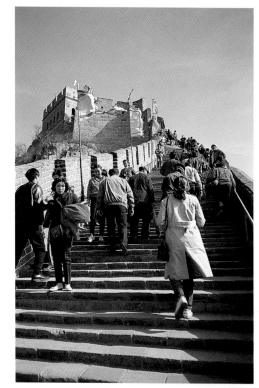

Roof patterns

Above There are exciting pictorial possibilities in photos like this one, taken from a high tower.

Stressing height

Right Tilting the camera slightly captures the upward thrust of the figures climbing up to the castle.

Unusual effects

Above Tilting the camera upward has created a distortion, suggesting a semi-abstract treatment based on the interplay of shapes.

Changing position

Left and above In the photo above, the two trees in the middle overlap in an awkward way, and are hard to read. This has been rectified by a slight shift to the right, which has also given a better composition.

Composition

- **Taking panning shots**
- **Varying the format**
- **Avoiding symmetry**

By choosing your subject and viewpoint you will already have begun to make compositional decisions, but you don't want to tie your hand too much and leave yourself with no choices at the painting stage. In order to make a successful painting from photographic reference you must see the photograph as just that – a reference, rather than an image to be copied exactly. So whenever you can, give yourself options and take three or four – or even six – shots of your chosen scene, rather than just one. For example, in a garden or a wide landscape, take panning shots from side to side and up and down. You can stick these together onto paper at the painting stage (see page 50) and then select which one you want. Also vary the format of your photographs, taking some in landscape (horizontal) format and others in portrait (vertical).

COMPOSITIONAL GUIDELINES
You should not ignore composition entirely when taking photographs, however, and there will be occasions when you may have to work from just one photo. There are few golden rules to remember about composition, but one is that a focus of interest, such as a tall tree or a building in the middle distance of a landscape, should not be in the exact centre of the picture. Apart from this, aim for a good balance of shapes: the vertical lines of trees, for example, might be balanced by horizontal shadows and perhaps the curve of a wall or fence. Also look for a balance of light and dark: most good paintings have a recognizable tonal pattern, without which they can look bland.

Balance of shapes
Below This is a pleasing composition, in which the picture space is divided in a harmonius way and there is a good balance of shapes, tones and colours.

Symmetry and asymmetry
Left This photo is too symmetrical, but the distant rock could be moved to the left. *Below* The interest is all on the right-hand side, lacking balance.

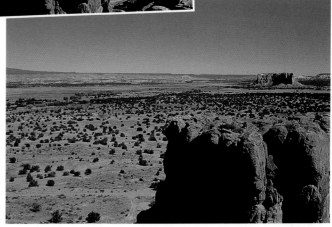

See also: Making a reference file (page 24)
Editing your photos (page 48)
Combining photos (page 50)

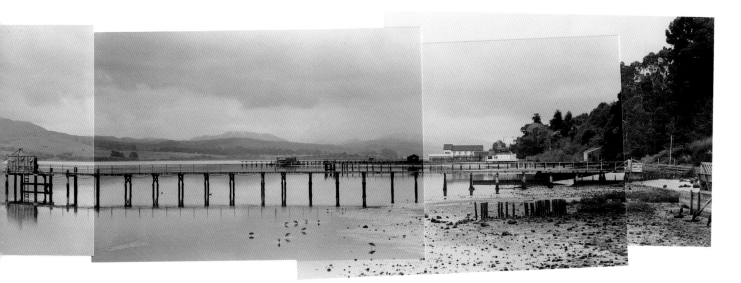

Panoramic views
Above Taking panning shots and joining them together has given a powerful impression of the sweeping expanse of water and the length of the pier.

Print Sizes

It is hard to work from small prints, as you can't see the detail clearly, so order the largest size that you can, at least 12.5 x 18cm (5 x 7in). Bigger prints are available, but they are more expensive, so save them for especially successful shots or enlargements of specific areas.

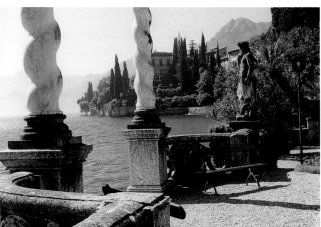

Planning the painting
Above The artist has planned the composition through the viewfinder, and has departed from it only very slightly, by cutting down the area of foreground wall. But she has given the painting extra interest by introducing light clouds, not visible in the photo.

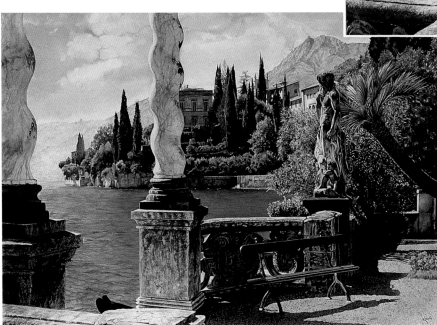

Villa on Lake Como, **watercolour**
Estelle Lavin

Making a *reference file*

- **More compositional options**
- **Adding interest**
- **Skies in composition**

Landscape paintings can sometimes fail simply because there is not enough interest in them and the viewer's eye is not drawn into the scene as it should be. Artists of the past would often include a figure in the middle distance to provide a focal point, to give a sense of scale or to add a colour accent. A red-clad walker, for example, makes a complementary contrast in a green, summer landscape, while a small figure emphasizes the size and dramatic impact of tall cliffs and mountains.

It is worth taking shots of people out walking, sitting on beaches or just going about their daily business, even if you have no immediate use for them. In this way you can gather a file of visual information that you can draw upon as needed; it is hard to paint figures from memory.

Reference shots of landscape details can also be useful. Close-ups of stones, walls, grasses and flowers, or, in urban scenes, street furniture such as lampposts and benches, may give you ideas on how to treat a featureless foreground.

SKIES

A file of sky photos is of special importance to the landscape painter because the sky can play a major role in the composition. Skies don't always come out well in photographs for a simple reason: unless they occupy over half of the picture area the camera will be taking its light reading from the land, and the sky, being brighter, will be overexposed. To overcome this problem, take separate shots of skies, including, if you like, just a sliver of land (which will be underexposed) so that when you are looking at lots of photographs you will know to which landscape the sky belongs.

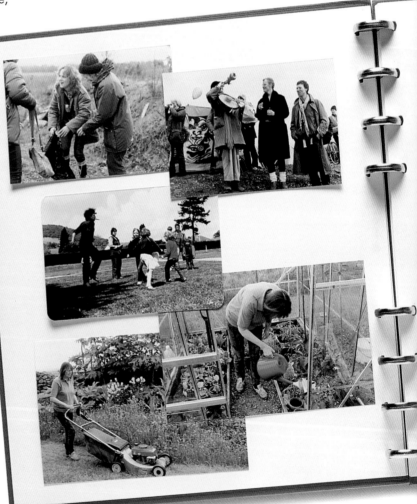

See also: Getting it in focus (page 28)
Light & dark (page 36)
Camera distortions (page 52)

Photographing skies
Left This photo was taken as a reference shot and later used in a painting of an evening landscape.
Far left Here, the sky is bleached out and clouds would have to be added from memory, or another photograph.

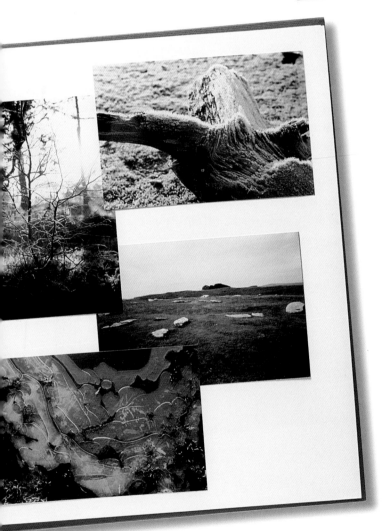

Labelling Your Shots

One of the problems with combining two separate shots for the landscape and sky is that they may not match: that is, you might pair an image of a midday sky with a photograph of a landscape that was clearly taken in the evening. This doesn't always matter, but if shadows are a feature take care, because they vary enormously according to the height of the sun. It is wise to label your photos with the time of day and season when they were taken, if possible, so that you can avoid such incongruities.

Setting sun, no shadows

Keeping an album
Above It is helpful to keep an album of details, textures, people and so on, as you may be able to incorporate these into your paintings. The tree trunk at top right, for example, could feature as a piece of driftwood in a seashore scene, and one or two of the figures could add interest to an urban scene.

Midday, minimal shadows

Choosing the *focal length*

- **Getting close to your subject**
- **Avoiding distortion**
- **Panoramic views**

If you have a zoom lens on your camera you will need to decide which focal length (see page 12) best suits your subject. This normally presents no problem as you can simply zoom in and out, bringing the subject closer or further away, until you are satisfied with the composition. But there are potential pitfalls, so it is helpful to understand the principle of focal length.

HOW FOCAL LENGTH AFFECTS THE IMAGE

When automatic cameras were first manufactured, a 35mm (wide-angle) lens was standard. This was foolproof – ensuring, for example, that all the people in a family group would be included in the photograph – but this focal length is not always useful for painting references. For landscape shots, it sometimes seems like a natural choice, because you can get so much into the frame. But by including more than you can actually see without moving your eyes, the camera distorts the view. Buildings, distant mountains and other tall elements look much smaller than they are in reality. You can get some idea of the effect looking through the viewfinder, but it becomes more obvious when you get the prints; indeed, you may even have difficulty recognizing a landscape subject and reconciling the print with what you saw. But the wide-angle lens has its uses: it is ideal, for instance, for sky reference shots (see page 24) and can also be effective for flattish, panoramic landscape.

The middle setting of the zoom, 50mm, will still reduce height to some extent, so for buildings, hilly landscapes or tall trees, 75–80mm is the best choice. If you can't fit in all that you want at the sides, take several shots and join the prints together (see page 50).

Maximum zoom is also useful for portraits and reference-file shots of landscape details as it brings the subject slightly closer without distorting it. But take care if the subject is close, because the depth of field (see page 28) becomes smaller as the focal length is increased, so you may not get the whole of the image in sharp focus.

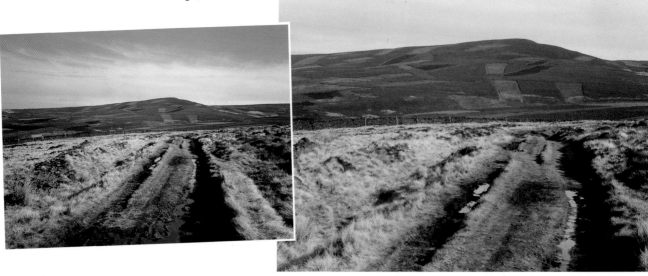

See also: Getting it in focus (page 28)
Camera distortions (page 52)

Distorting for effect
Above The photo above was taken at the middle setting of the zoom lense, 50mm. The one to the left was a wide-angle shot, with the zoom set at 35mm, and although not a true record of the scene, it does create an exciting feeling of space.

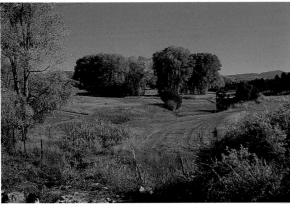

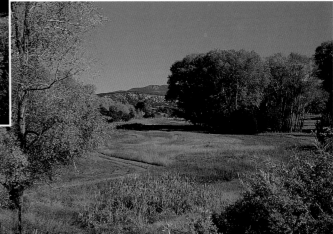

Varying the focal length
Left and below Two different focal lengths were used here, mainly to provide compositional options.

Zooming in
Below and right In the wide-angle photo (below) the rocks lack impact and the distant mountain has lost height. Zooming in (right) creates a more exciting image. The two could be used together to create a painting with the best features of both.

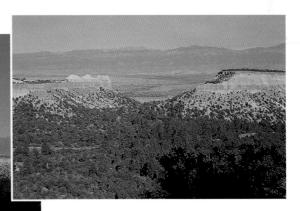

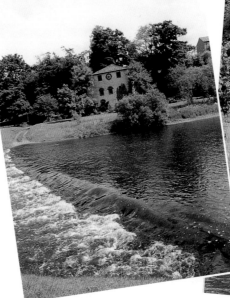

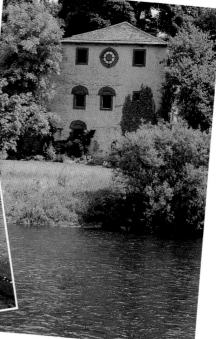

Composing with the zoom
Right The right-hand photo was taken with the focal length at 85mm, to emphasize the seclusion of the house surrounded by trees. The artist then decided that pulling back to include the weir would lead the eye to the house, so he took this shot at 28mm (near right).

Getting it *in focus*

- **Ensuring sharp images**
- **The eye of the camera**
- **Giving yourself extra information**

With an automatic camera the focusing is done for you, but you can still make mistakes and end up with blurred images simply because you have inadvertently focused on the wrong thing. The little 'eye' that operates the autofocus mechanism is in the middle of the viewfinder, so if you are photographing a landscape detail that is not directly in the centre of the viewfinder, or a child who moves at the crucial moment, the background will be in focus but the subject will not. Most good automatics have a focus lock to overcome the problem, which is doubly useful as it also locks the exposure.

DEPTH OF FIELD

The other reason for blurring occurring in photographs (usually in the background) is that the depth of field – a phrase that indicates how much of the subject will be in focus – is too small to cope with both near and distant objects. Depth of field is determined by three factors: the size of the aperture, the distance from the camera to the subject, and the focal length. If the subject is more than 9m (30 feet) away from you the whole scene will be in focus from that point to 'infinity', whatever the aperture and focal length, but if it is close, say 3m (10 feet), and you are shooting at f.4 (a wide aperture) at maximum zoom, then neither the background nor the foreground will be in sharp focus. Depth of field increases progressively as the aperture becomes smaller.

 With compact cameras you have no control over the aperture, but it is still useful to understand the principle of depth of field. If you know that you want sharp foreground or background detail in your photograph of the child playing, take separate shots of these and combine them all when you are painting.

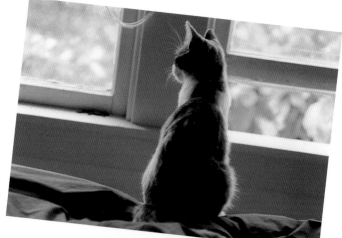

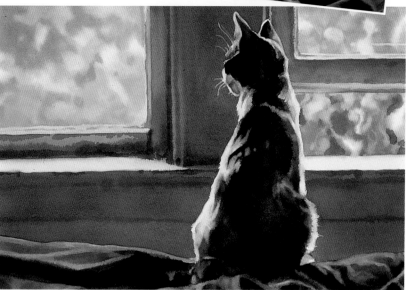

Cleo by the Bedroom Window, **watercolour**
Karen Frey

Using effects of the camera
Above Sometimes sharp focus does not matter much for paintings – a blurred effect can give you ideas. The out-of-focus foliage in the background has been exploited in the painting, and it was easy enough to sharpen up the windowsill and the cat's body.

See also: Close focus (page 30)
Movement (page 38)

Out of focus photos

Left In the far photo, the flowers are blurred because the photographer misjudged when using a manual SLR. At near left, an autofocus camera focused on the centre of the image, but the subject of interest was off-centre. Focus lock would overcome this problem.

Long depth of field

Below Here the artist sef his SLR to a narrow aperture (f.32), so that all the components of the image were recorded sharply.

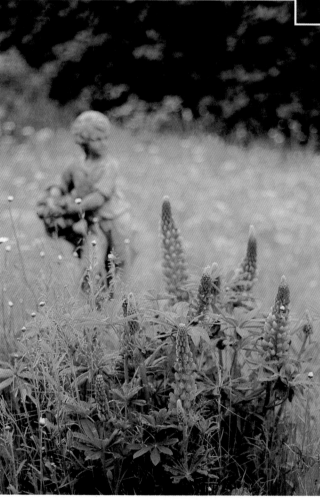

Narrow depth of field

Above This photo was taken with an SLR, using a wide aperture (f.4) and focusing on the flowers. All the background is out of focus.

Close *focus*

- **Flowers and small objects**
- **Close-up details**
- **Recording textures**

Automatic cameras cannot focus on anything that is nearer than about 90cm (3 feet) (with slight variations from model to model), but those with a zoom lens have a facility that allows for so-called 'macro' shooting. This does not actually enlarge the image, but it does allow you to move as close as 60cm (2 feet) to the subject. With an SLR camera, with or without a zoom lens, you can usually focus from about 1½ feet (45cm) upward.

Most painting-reference photos are taken from a distance of at least 4.5m (15 feet), but it can be useful to get closer to the subject on occasion. Shots of flowerheads, branches of spring blossoms or shells on a beach can be exciting starting points for paintings, especially if you enjoy detailed, small-scale work. You might also find it interesting to take close-ups of textures

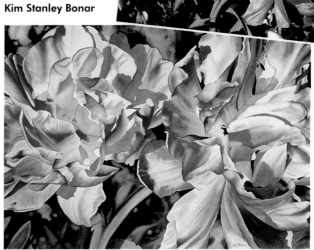

Pretty in Pink,
watercolour
Kim Stanley Bonar

Flower painting
Above A portion of this close-up was chosen for the composition and the rest of the photo was masked off.

and patterns, such as tree bark, rough stonework or the swirling patterns of a cut cabbage. Once you start doing close-up work you will discover a wealth of possibilities, including the option of semi-abstract interpretations.

Focusing on detail
Left Any of these close-up photos would make good starting points for larger paintings or could be used directly for botanical studies.

See also: Getting it in focus (page 28)
Photographs from television (page 44)

POINTS TO WATCH

As explained previously, the closer the subject is to the camera the less the depth of field, so you must accept that only a small area of the picture will be in focus. Take especial care when focusing: if you are recording a flowerhead with an automatic camera in macro mode, for example, make sure that the flower is in the centre of the viewfinder as you focus, and then use the focus lock (see page 28). With an SLR camera, which is heavier, even a slight shaking of the hands will move the subject out of focus and there is a danger that this may happen as you press the shutter release. For the best results, a tripod should be used (see page 45), but if you don't have one, try to wedge yourself against a wall with your elbows pressed into your body.

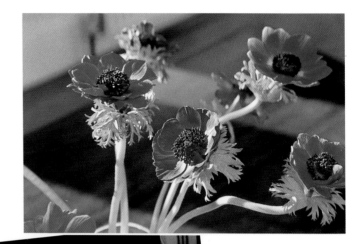

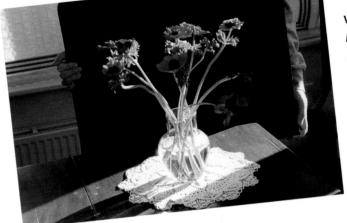

Visual information
Left To provide adequate reference, the flowers were photographed both as a group and in close-up.

Horse Chestnuts
watercolour
Matthew Wilkins

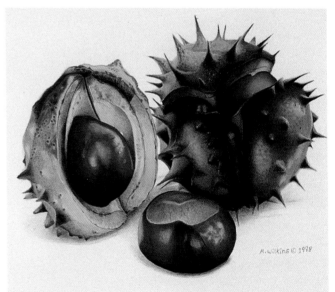

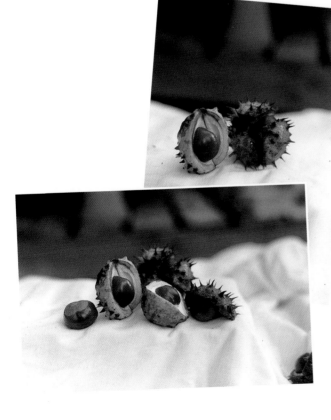

Sketching with the camera
Above The subject was explored from various angles with the camera, but the artist was not concerned with composition at that stage. The placing of the objects was decided at the preliminary drawing stage.

Exploring *natural light*

- **Light and colour**
- **Choosing the best time of day**
- **Exploring unusual effects**

All landscape painters, photographers and, indeed, anyone who spends time outdoors, will have observed how light affects colours and how they will change from sparkling and vibrant to dull and dead as clouds and rain sweep in. But it is not until you have looked at the same subject under a variety of lighting conditions that you will fully appreciate the relationship between light and colour.

It is not just the presence or absence of the sun that changes things; it is also its intensity and position in the sky. At midday in summer the sun is high and bright and bleaches out the colours, so unless you want this effect avoid taking photographs at midday except in winter, when the sun remains low throughout the day. A low sun gives not only the best colours, but also the long shadows that can play a major role in your composition. Early evening is an especially good time for photographing buildings, as the sinking sun imparts a lovely golden glow and casts distinctive shadows that explain the structures and shapes of doors, windows and balconies.

OVERCAST CONDITIONS

Even when there is no sun there is still light, and although the colours of the landscape are heavier or more muted on overcast days they can nevertheless provide interesting painting potential. The great French painter Camille Pissarro, who worked in England for a time, liked gentle, lightly clouded skies, which produce a close range of middle tones with no strong light or dark shades. Misty days can also be exciting: there is nothing lovelier than early-morning mist on water, or trees appearing like ghosts through a gauzy, atmospheric veil.

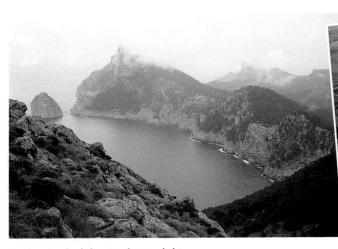

Low-hanging cloud obscuring direct sunlight

Early morning sun casting long shadows forward and catching the tops of the trees

Painting light
For some landscape painters, light forms a major theme. These three photos were taken to record different effects.

Low evening sun reflecting on the water surface and silhouetting the rocks

See also: Low-light photographs (page 34)
Light & dark (page 36)

Series paintings
For this series, showing the same winter scene at different times of day, the artist has drawn on memory to a large extent, using the photo as reference for the tree shapes, but sometimes rearranging them.

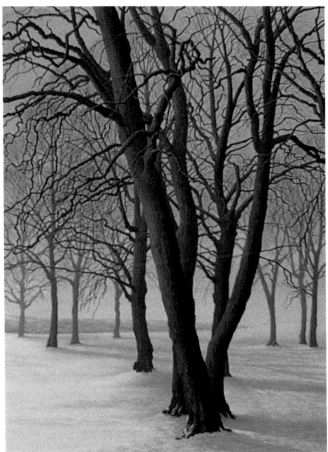

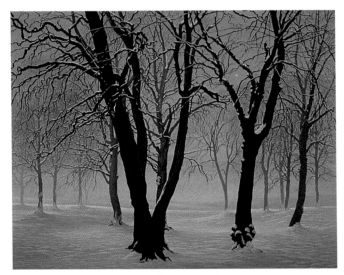

Winter Afternoon, watercolour and gouache, Jean Canter

Evening Star, watercolour and gouache, Jean Canter

January, watercolour and gouache, Jean Canter

Winter Morning, watercolour and gouache, Jean Canter

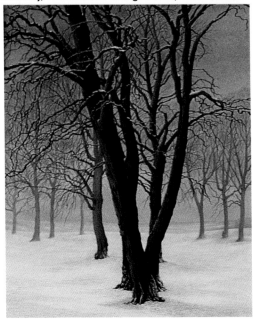

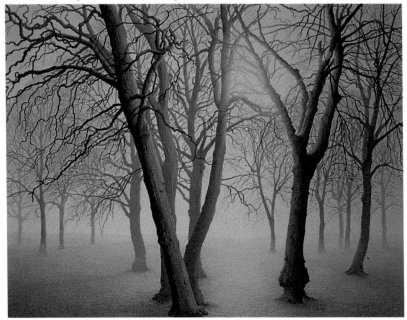

Low-light *photographs*

- **Recording colour effects**
- **Choosing the shutter speed**
- **Avoiding camera shake**

Most of us will have noticed how wonderful the colours of a landscape are at dusk or just before it. The reflected glow of the sinking sun produces a rich range of purples, deep blues and blue-greens in land and water, and often transforms prosaic buildings or roads into slabs of pure colour. There is seldom time to capture these effects in paint, but they can be photographed.

Sadly, not all automatics can cope with dim conditions. If you have a model with a built-in flash it will compensate for the lack of light by taking a flash photo, which won't give you a true record of the colours. The more sophisticated automatics allow you to turn off the flash so that you can take shots at a slow shutter speed. If you try this, however, remember to take the light reading from the land rather than the sky and use the focus and exposure lock (see page 28), or the land will be very badly underexposed, possibly almost black.

SLOW SHUTTER SPEEDS

Most SLR cameras will give you light readings in quite dim conditions, allowing you to take photographs at $^1/_{15}$th of a second to 1 second, or even make a self-timed exposure of several seconds. The slowest shutter speed that you can use without jerking the camera when you press the shutter release is $^1/_{30}$th of a second, so you will need to support it. A tripod is best, but you can also try propping up the camera on a convenient wall or car roof. The self-timer is a useful device for this kind of work because it releases the shutter more smoothly than you can by pressing the button. If your photos do come out a bit blurred it may not matter because you will be more concerned with colour than with detail.

Low-light photos
These photos were all taken without a tripod, instead using a harbour wall, a fence or a car roof to lean against and so hold the camera still for long exposures (up to $^1/_4$ second).

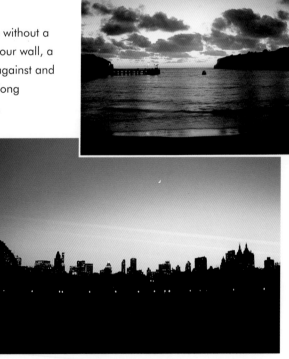

Seascape just after sunset

Central Park at dusk. The buildings and park are too dark, but this effect could be used to make an evocative painting of the sky's colours

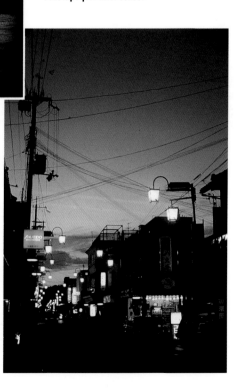

See also: Exposing the film (page 14)
Light & dark (page 36)

Dramatic dusk shot, making a feature of the streetlighting

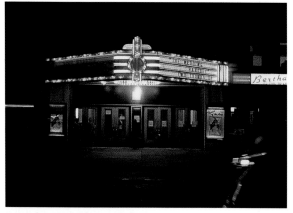

Main reference shot for neon lighting

Painting artificial light

This artist enjoys exploiting the contrast between natural and artificial light seen at dusk or just before. He works in oils in a photorealist style, and often requires several photos to provide sufficient information on detail.

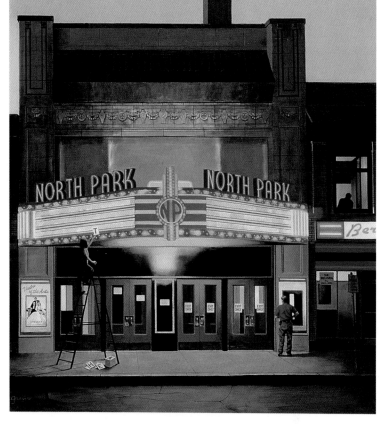

Reference shot for figure

At the North Park, oils, Walter Garver

Reference for shapes and structures of the building

Backup reference for colours of neon lighting and dusky sky

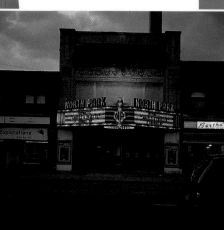

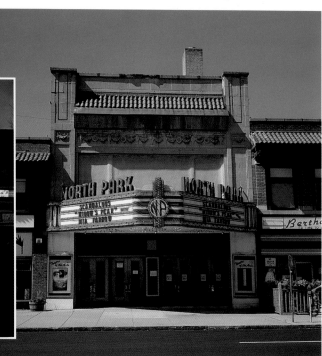

Light & *dark*

- **Limitations of the camera**
- **Shadow colours**
- **Taking multiple photographs**

The camera is a wonderful tool for the artist, but it is not perfect, and unless you recognize its limitations and learn how to deal with them you will, on occasion, find your photographic references disappointing. The camera's main failing is that it can't deal with extremes of light and dark. If you look at a sunny landscape or an urban scene, or a landscape that is partially covered by snow, you will have no difficulty in analyzing the colours of the shadows, as well as all the nuances of colour and tone, from bright to dark. But the camera is less efficient than your eyes and brain, and it will register either the

lights or the darks. So, depending on which area the light reading is taken from, you will end up with near-black shadows on the one hand, or colourless, bleached-out highlights on the other.

THE MORE THE BETTER

In such circumstances it is really essential to take as many photos as possible, or you simply won't have the colour references you will need. Shadows may play a vital role in your overall colour scheme, so when you have taken a general shot or two, focus on the shadows – if you are using an automatic, use the focus and exposure lock (see page 28) and, for an SLR, take the reading from the shadows. The same applies to dark features in a snow scene: for example, a shadowed stone wall or a group of dark trees may come out almost black, with all detail lost, if the reading is taken from the snow. An interesting exercise for SLR owners is to train the camera on different parts of the scene and note how dramatically the light reading changes.

Exposures for high contrast scenes

Your eyes are much more flexible than a camera, because they adjust instantaneously to the amount of light received as you glance between areas of sun and shadow. Mimic this by taking a series of photos of different areas so you can record all the detail you need for your painting.

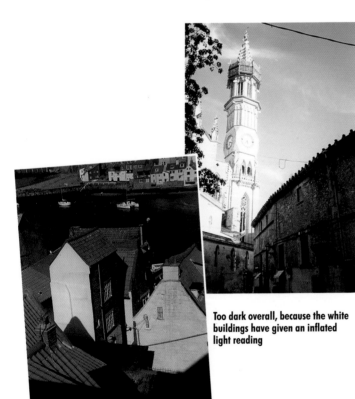

Too dark overall, because the white buildings have given an inflated light reading

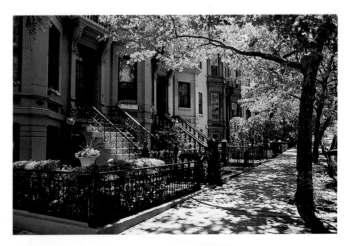

Well exposed, as there is an even distribution of lights and darks

See also: Exposing the film (page 14)
Combining photos (page 50)

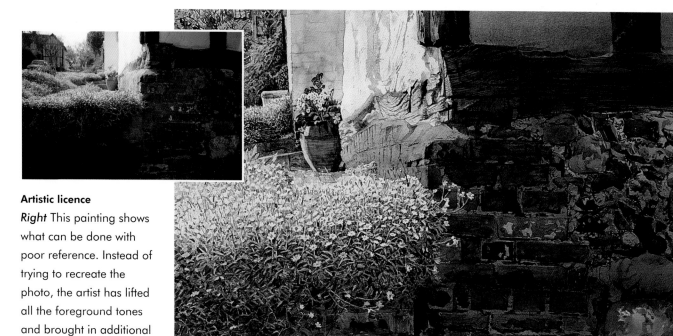

Artistic licence

Right This painting shows
what can be done with
poor reference. Instead of
trying to recreate the
photo, the artist has lifted
all the foreground tones
and brought in additional
colour and detail.

Snow in Summer, watercolour
David John Griffiths

First Snow, watercolour
Melanie Lacki

Adding colour

Left The photograph,
although adequate, has
failed to capture the lovely
blue shadows seen on sunlit
snow. The artist has made a
feature of these in the
painting, exploiting both the
colours and the shapes made
by the shadows.

Movement

- **Moving water**
- **Figures in movement**
- **Freezing the image**

An ever-popular subject for painters is moving water, whether rippling around rocks in a shallow stream, cascading down through a ravine in foaming plumes, or breaking in waves and spray on a seashore. These are among the most challenging of all painting subjects, and they also call for a degree of craft on the part of the photographer. When we watch waves, we take in the whole process, from the gradual upward swelling of the water to the thunderous shattering on rocks or sand. But the camera captures just one split second of this drama: the movement is frozen, and thus the photographs often look dull. Likewise, photographs of ripples or waterfalls frequently fail to convey the excitement of the movement, with the water looking solid and static.

If you have an SLR camera, try using a slower shutter speed than usual, say $^1/_{60}$th or even $^1/_{30}$th of a second. This will create a slight blurring effect that will give a better impression of movement than a standard speed. With an automatic, you will simply have to take the photographs and then try to convey the movement of the water by the way in which you use your brush or pastel marks when creating the painting.

SPORTING ACTIVITIES

People playing sports, riding in horse races or dancing are other challenging subjects. You could use a slow shutter speed here too, or you could deliberately freeze the image; unlike water, the figures won't look static because the bodies themselves will express movement. The main difficulty will be focusing, so use a fast film to give as much depth of field as possible. If the subjects are all at roughly the same distance from the camera, as in a horse race, find a static object on the same plane and focus on this first.

Frozen movement

Below In these two photos a fast film and short exposure time has been used to freeze the motion of the waves and cyclists, but the positions of the cyclists and yachtsmen make the images read well.

Blurred water

Below The slightly longer exposure time used here gives a blurred effect, making the shapes of the waterfall clear and giving a softer atmosphere.

See also: Exposing the film (page 14)
Getting it in focus (page 28)

Emphasizing movement
Right The walls and window are sharp, clear, and solid-looking in the photo, but the artist has emphasized the theme of movement by treating the wall almost as though it too is moving, with her brushstrokes making a lively, dancing pattern.

Breeze, Samos, **watercolour**
Linda Kooluris Dobbs

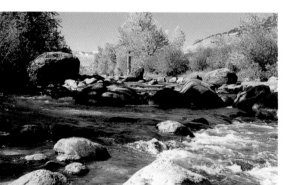

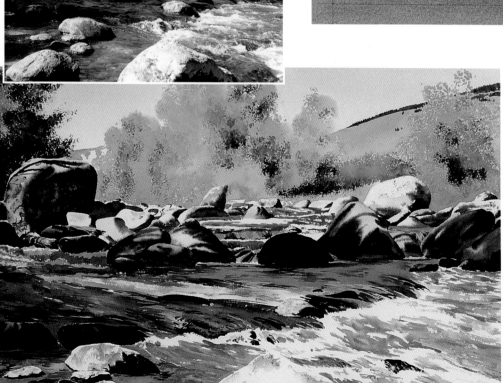

Brushwork
Left The photo, though good in terms of colour, has not captured the movement of the water. In the painting, however, the water is full of movement, an effect achieved by using long, directional brushstrokes that follow the flow and describe the way the water runs over hidden stones to form crests of foam.

The West Boulder,
watercolour
Loren Kovich

Indoor *subjects*

- **Fleeting light effects**
- **'Found' still lifes**
- **Light and shade indoors**

Because a still life is a static subject that isn't going to change or move, there is not usually much point in photographing it. However, sometimes you long to catch a particular light effect, such as a light-and-shadow pattern cast by the bars of a window, or the dramatic shadows created in front of objects by the light behind them. These won't last long and it is well worth taking a photograph, but you may not succeed when painting if you try to work entirely from photographs because they will probably flatten out the objects, make the details hard to read and fail to capture the more subtle colour shifts and variations. If the objects are your own, set them up again when you have the prints and work from a combination of actual still life and photograph.

Photographs are also useful for 'found' still lifes, a phrase that describes something that you just happen to discover rather than a deliberate set-up that you can leave in place until you have finished. You might see painting potential, for example, in the detritus of a left-over

meal, in vegetables that have just been unpacked from carrier bags or in an untidy scatter of books, magazines and knitting wools on a sofa. Again, you may need to check the details of some of the objects when you paint.

INTERIORS

Interiors – which can include simply a corner of a room or a chair against a window – are another kind of found still life. They are subjects that are full of potential but which are often overlooked by amateur painters. One reason for this is that it can often be difficult to find the right place in which to set up your easel or worktable, and here, too, the camera can help. If you see something in your own home that inspires you, for instance, such as sunlight falling on rumpled, early-morning bedclothes, or pools of evening light on sofas and chairs, get out your camera and make notes. If you have taken wide-angle shots there will be some distortion, but you can check the proportions at the painting stage.

Mum's Sealers, **watercolour, Joan I. Roche**

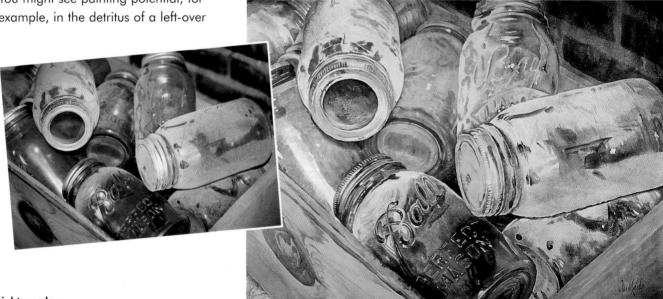

Light on glass
Above Transparent and reflective objects are very much affected by changes in light. If it is impossible to set up a still life in unchanging lighting conditions, it can be more satisfactory to paint from photographs.

See also: Choosing the focal length (page 26)
Light & dark (page 36)

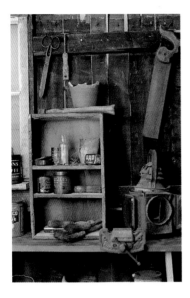

The Garden Shed, **watercolour**
Matthew Wilkins

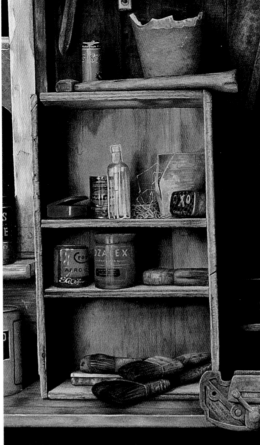

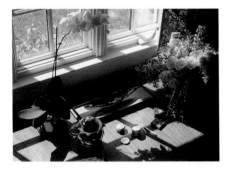

Found still life
Above The artist couldn't paint this diptych of a ready-made still-life on the spot, due to lack of space.

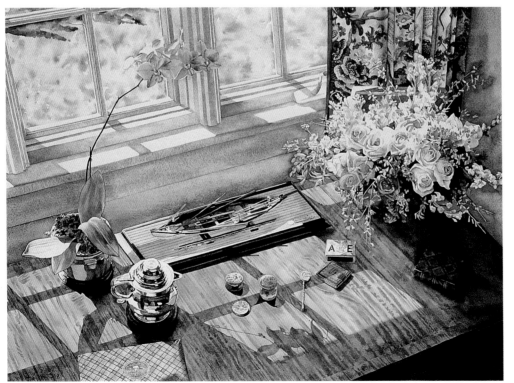

Light and shade patterns
Left The photograph was taken to record the shapes made by the cast shadows, but it does not provide adequate reference for the colours of some of the objects. However, since this is the artist's own home, he was able to check details and decide on the colour scheme at the painting stage.

Still Life with Whitbread Bouquet, **watercolour**
William C. Wright

Figures *& portraits*

- **Photographs as back-up reference**
- **Informal portraits**
- **Outdoor figure paintings**

Most artists agree that portraits painted entirely from photographs lack conviction, except in the most skilled hands. There is often a stiffness about them and, apart from this, photographs don't always give you all the information that you need to paint a convincing portrait. As a back-up reference to one or two sittings, however, they are extremely useful, and many professional portraitists use them in this way, since few people can spare the time for the repeated sittings that are often necessary. The best focal length for portraits and figures is 75mm, which will give minimum distortion.

For informal portraits and figure paintings, such as a child watching television, someone cooking, doing carpentry work, gardening or simply relaxing in the sun outdoors, photos are ideal and give you the advantage of being able to capture movement. With such subjects details of facial features will be less important than shapes and postures, and the setting will play as much of a part in the composition as the figure, so provide yourself with plenty of information on this.

FIGURE GROUPS

The camera also comes into its own for figure groups, perhaps people sitting at a café table in a holiday resort or picnicking on a beach. These are always attractive subjects but are difficult to paint from life unless you can work very fast. Take several shots so that you have a number of compositional choices, and if your camera has a zoom lens use the maximum zoom in order to avoid being intrusive. If there are any particular colours that you want to feature, such as on clothing or striped beach umbrellas, make separate notes of them in case the photographs don't capture them all (see page 18).

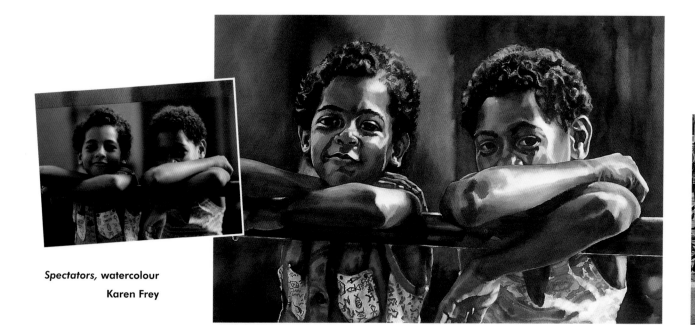

Spectators, **watercolour**
Karen Frey

Capturing fleeting moments
Above This delightful painting obviously could not have been done from life, and the artist took great care to ensure that the photo provided good reference.

See also: Looking & thinking (page 18)
Choosing the focal length (page 26)
Light & dark (page 36)

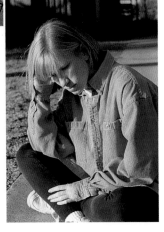

Realistic figures
Right A person holding a pose will never be quite as realistic as in action. Snap away for your reference file.

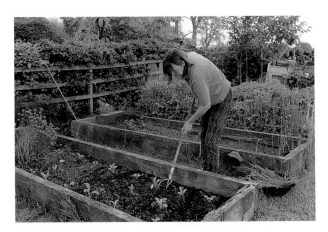

Be Still and Know, **watercolour**
Kim Stanley Bonar

Expression
Right The posture of the girl deep in thought was easily captured by the camera to provide the basis of an unusual and effective figure study.

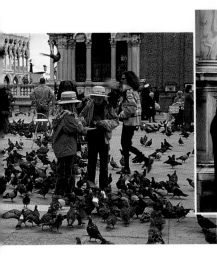

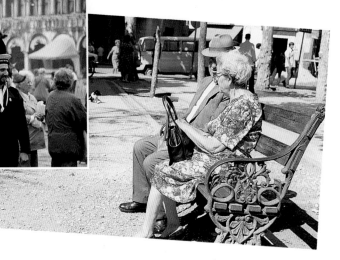

Figures in a setting
Above These three photos all have the potential to be used for paintings, especially the one of the two figures on the bench, which could be cropped to make an upright composition.

Photographs *from television*

- **Freezing moving subjects**
- **Making video stills**
- **Photographic hints**

Television plays a large part in most of our lives, but although we may respond to certain images and effects we don't often think of them in terms of painting potential. But you can take photographs from the television and videos, and some artists find that such photographs provide them with visual references that they would not normally come by. Sports are a case in point: even if you regularly attend tennis matches or football or rugby games, you are not usually close enough to sketch or photograph the players, but by taking photographs from the television screen you can get in close and freeze the movement.

There are many other sources of inspiration in this area, too. You may, for example, have a favourite film that you have always admired for its camera effects, lighting values or the composition of individual shots. If so, you could buy or hire the video to take photographs from, which will allow you to freeze the frame temporarily while you get the camera into position.

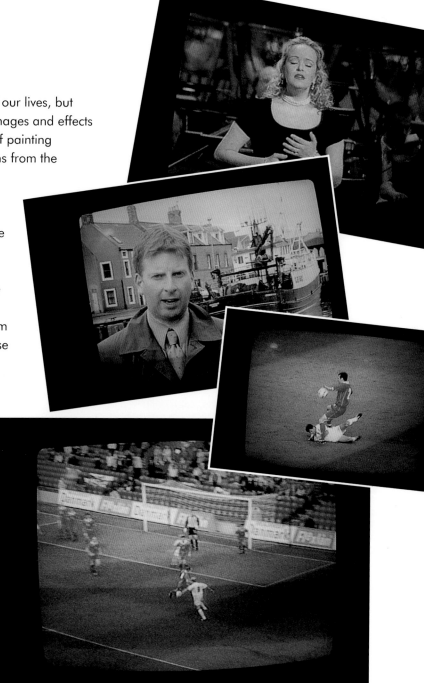

Action and variety
Above Whether you want action shots of sportsmen or a variety of facial expressions that you can add into other compositions, taking photos from television will literally bring the whole world in front of your camera.

See also: Low-light photographs (page 34)
Movement (page 38)

Tripod and Cable Release

All SLR cameras have a screw socket on the bottom to enable them to be mounted on a tripod, as well as another on the top to take a cable release. When the button on the end of the cable is pressed the shutter is released smoothly, without you having to touch the camera. This combination is useful for photographing television and video stills because you can set up the camera in a fixed position and activate it from a slight distance.

CAMERA WORK

The best camera to use is an SLR, which will enable you to choose the shutter speed. A good choice is $^1/_{60}$th of a second, but you could go down to $^1/_{30}$th if you don't mind a little blurring, which can give an impression of movement. You may find it helpful to use a tripod and shutter-release cable, but these are not essential.

With an automatic camera it is more of a hit-and-miss affair, and you may not be able to pull it off at all. A good zoom-lens automatic will allow you to get reasonably close to the screen and will use a slow shutter speed if you can turn off the flash. Alternatively, you could try using the flash, which may give you an image that is good enough to work from.

Using videos as sources
Below The source photo for this watercolour was taken from a film about the life of jazz musician Bix Beiderbecke. The artist shot the image from her television at $^1/_{60}$th of a second using an SLR camera. The painting uses a limited but warm palette of colours.

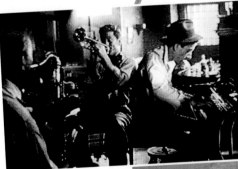

In the Café, **watercolour**
Morag Burton

Preparing to paint

A photograph does not always translate satisfactorily into a painting without some alteration; you may want to change the composition, heighten the colours, or bring in extra features. You might find it challenging to work from monochrome press images or old family photos. This chapter provides some ideas on gathering visual information and planning your paintings from photo to sketch or preliminary drawing, together with some basic facts about the painting media.

Editing *your photos*

- **Varying the format**
- **Working out the composition**
- **Making enlarged photocopies**

If you have an especially successful photo in which composition works well, you may choose to include all of it in the painting, sticking to the same format. It is always worth exploring other possibilities, however, such as concentrating on one area of the photograph, or changing a horizontal into a vertical. To frame the subject in various ways, cut out two corners from white card and then move them around on the photograph until you see a possible composition emerging. You may find that even a rather dull photograph gives you some new ideas once you begin to isolate certain parts of it.

ADDING AND SUBTRACTING

Landscape paintings, especially flat ones and those that feature expanses of water, often work best if the sky occupies a relatively large part of the picture area. If your photos don't show enough sky, you can easily add more to the painting, particularly if you have a reference file of sky photos to work from (see page 24). To see how the composition will look before you start to paint, stick the photo down onto a sheet of paper and roughly draw in the new sky with a medium such as pastel or coloured pencil. You can do the same with foregrounds: for example, you may find that you can convey a greater feeling of depth and recession in a landscape by incorporating a large, broadly treated area of foreground, which will push a focal point – such as a group of trees or a building – farther back in space.

Deciding what, if anything, to leave out, is more difficult, as you can't blot out parts of a photograph. Sometimes these decisions have to be left to the preliminary drawing stage, but resist the temptation to

include everything in the photograph just because it is there. To simplify an image, make a few quick, thumbnail sketches (see page 56) first, leaving out anything that doesn't seem to help the composition.

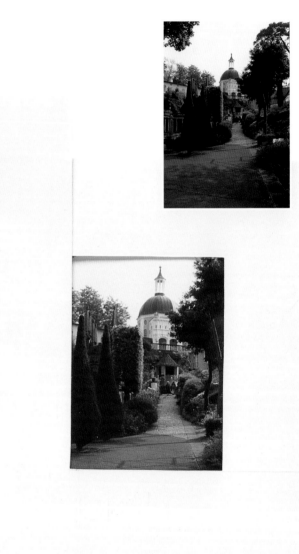

See also: Making a reference file (page 24)
Combining photos (page 50)
Drawing for painting (page 56)

Looking at separate areas
Above The whole photo is too cluttered, but using card corners the artist chooses a small area that makes a good composition on its own.

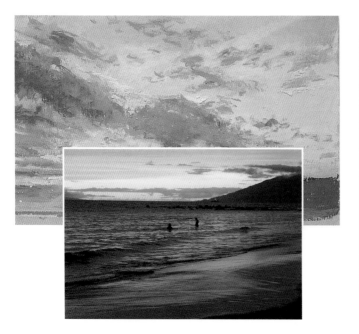

Colour to Black and White

Paintings created from photos sometimes fail simply because the artist has tried to copy the colours of the photograph too exactly, without thinking about how the painting itself is developing. Making an enlarged photocopy of a photo, then drawing on memory for your choice of colours, is often an interesting exercise. (More information about working from monochrome on page 55). Another reason for making photocopies is that you can trace them off directly onto the picture surface instead of making a freehand drawing (see page 56).

Balancing the composition
Above The artist was trying to capture the quality of the light on the waves, but when she studied the photo she felt that the composition was unbalanced. By showing more of the sky, extended from memory, she achieved a more expansive image.

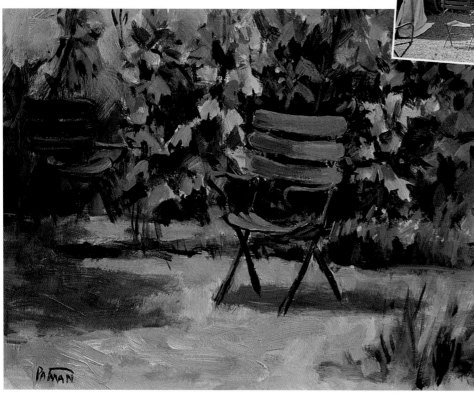

Working from detail
Left The artist has made a strong statement by focusing in on the garden chairs, choosing just two of them and rearranging them to suit the composition. She has painted them in darker, richer colours than in the photo, and has brought in softer but more colourful shadows.

***Garden Chairs,* oil**
Rebecca Patman Chandler

Combining *photos*

- **Keeping the colour consistent**
- **Avoiding odd effects**
- **Taking a wider view**

If you have taken panning shots of a landscape (see page 22), you should not have much difficulty in combining elements from two or three of them, but you will find that even when the photos were all taken at the same time there will be variations in their colours and tones, depending on where the light readings were taken from (see page 14). You will have to decide which of the photographs is most true to the colours that you remember and then base your colour scheme on this, using the other shots only as references for shapes and structures.

More ingenuity is needed when it comes to photos that were taken at different times of day or in different places. You may decide that a garden scene could benefit from an additional feature taken from your reference file (see page 24) to give it more interest, such as a bench or figure. If the main scene was shot on a sunny day and the bench or figure on an overcast one, you will have to invent shadows in one place or play them down in others, or else the painting won't hang together.

Taking a sky out of its context can also create problems; don't use a light-and-shade landscape with a dramatic, stormy sky, unless you create a break in the clouds for the sun to shine through – this can create a very exciting effect, as it conveys the impression of fleeting light.

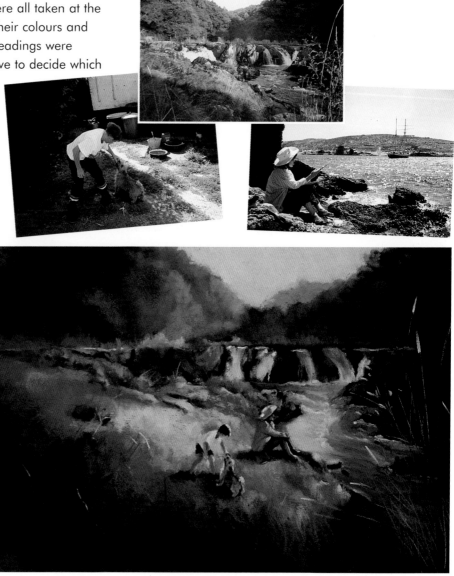

A Peaceful Afternoon, **pastel**

Christine Russell

**See also: Viewpoint (page 20)
Drawing for painting (page 56)**

Including figures

Above The landscape photo provided the setting, while the figures came from the artist's reference file.

VIEWPOINT AND PERSPECTIVE

The other thing that can go wrong in a painting is that the perspective can look illogical because you have tried to combine two photos taken from different viewpoints. This is especially noticeable in paintings of buildings, in which a slight shift from left to right or up and down can change the perspective considerably. In this case, you will have to decide on one 'master' photo which will give you the main lines of perspective, after which you can add details from others, or include additional buildings, always making sure that the viewpoint appears consistent.

Buildings

Combining these two photos would need to be done carefully, because the viewpoint is not the same, which affects the perspective. The photo above has been taken from a lower perspective, and the buildings converge more sharply.

Panoramic Collages

A single photo often fails to convey the feelings that you had about a subject when you saw it. In a landscape, for instance, it is frequently the sheer spaciousness that appeals, while in a park or garden it may be the patterns made by massed flowers of different colours, intersected by pathways and walls. To give yourself more ideas and

choices, take lots of photos and make a collage. Even if the colours vary and some photos are not quite in focus, a collage will give you an overall view that may provide a better starting point than just one picture, however good it may be. If you have an APS camera (see page 10) you could try the panoramic or wide view setting.

Pan the camera round while keeping it at the same level

Stick prints together with clear tape and then decide on the best section of the view

Camera *distortions*

- **Sky and shadow colours**
- **Adding height**
- **Correcting distortions**

A photograph does not always present a true record of colours, and you may have to change them to some extent when you paint. Clear skies, for example, tend to come out in photographs as a solid block of cyan blue, which does not look realistic, so try to draw from memory for the sky colour and avoid painting it an overall flat blue. If you use an opaque medium, such as oils, acrylics or pastels, you can create a more exciting sky effect by laying one colour over another, or by juxtaposing colours, using short brushmarks or pastel strokes.

If shadows appear dull and grey in the photo, you can pep them up, but bear in mind that shadows vary and their colours are dictated by two factors. They take much of their colour from the surface on which they are

cast, but they also reflect the sky colour. Shadows on grass will be blue-green while those on red brick will have a purplish hue resulting from the mixture of red and blue. A common mistake is to paint all shadows blue, regardless of the underlying colour.

HILLS, MOUNTAINS AND BUILDINGS

As explained on page 26, a photograph taken with a focal length of between 35 and 50mm will reduce the height of such landscape features as hills and mountains. Remember this when you make your preliminary drawing, and compensate for it by increasing the height of such features at least one-and-a-half times.

The same thing happens in photographs of tall buildings, and in this case there is sometimes a further distortion: if the photograph was taken from a low viewpoint the vertical lines will slope inward and begin to converge. This is merely an exaggeration of a perspective effect in which both vertical and horizontal lines appear to meet at what is known as the vanishing point. The lines can easily be straightened in your drawing, or else you can accept the distortion, which can give an interesting effect.

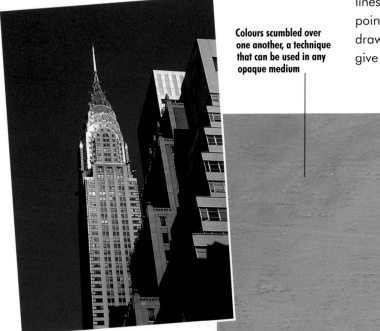

Colours scrumbled over one another, a technique that can be used in any opaque medium

Painting skies

Above Some artists might use this solid block of midnight blue to create a dramatic painting, but for a more realistic effect you would need to lighten the colour and introduce some variation. The method depends on the medium used.

See also: Choosing the focal length (page 26)
Light & dark (page 36)
Choosing the medium (page 58)

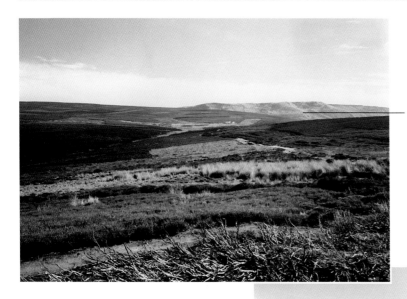

With the focal length of the camera set at 35mm, the mountains appear much flatter than in real life

A sketch will record your impression of how the proportions appeared to your eye.

Zooming in slightly has helped a bit, but a longer zoom lens is needed

Losing the drama
Above and right Photographs often fail to convey the drama of hills and mountains. The photo above is a wide-angle shot, in which the mountain range has almost disappeared, and even in the other, right, taken at 75mm, they have lost height. If you know the scene well, you can compensate for the camera's failings; otherwise, make backup sketches.

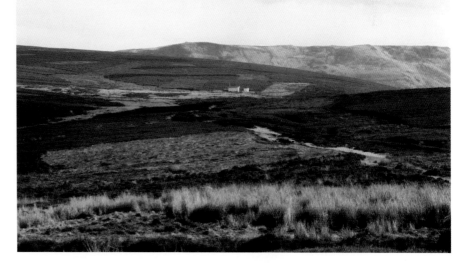

Converging verticals
Left This effect is common in photos of tall buildings, and is impossible to avoid without specialized photographic equipment. You can straighten the lines in a painting – and never be afraid to use a ruler – or use a modified version of the effect, which is a good way of emphasizing height.

Outside *stimulus*

- **Collecting visual information**
- **Translating an image**
- **Working from black and white**

Some people work exclusively from photographs that they have taken themselves, while others respond to images they see in books, magazines or newspapers, and use them as starting points for a personal interpretation. There is nothing wrong with basing paintings on other people's photographs, but the important word to remember here is 'basing': if you copy an image exactly and then try to sell your painting you may find yourself in the law courts because the copyright belongs to the photographer, not to you.

As long as you remember this, it is well worth collecting images that may interest you. Press photographers cover subjects and locations that are frequently not available to the ordinary person, and can also, of course, catch fast movement better than an amateur with an automatic. Books on wildlife and botany can be a source of inspiration, too, showing you exotic birds or flowers that you might not otherwise see.

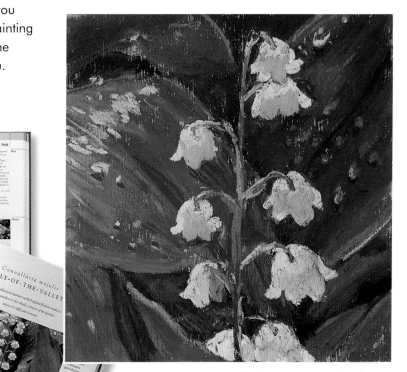

Create your own composition when using book images as reference.

Keep albums or scrapbooks of useful images from magazines, postcards or friends' photos.

Extra sources of reference

Above Postcards, pictures in books, photos that your friends take – all these can be fruitful reference for an artist. Do remember, though, that they should only be a starting point for your work, as direct copying would infringe the photographer's copyright.

See also: Making a reference file (page 24)
Photographs from television (page 44)
Editing your photos (page 48)

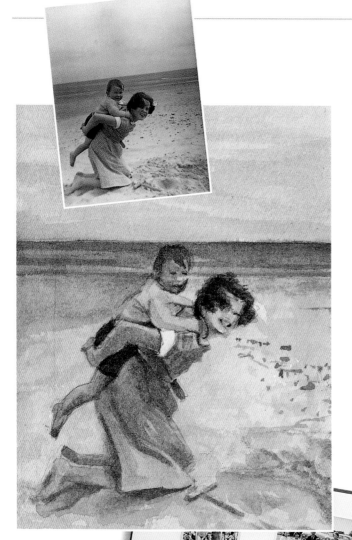

WORKING FROM MONOCHROME

If you paint flowers, birds or animals, you will usually need colour references, and it is also hard to work up landscape paintings from monochromatic images. But for some subjects, such as groups of people, sportsplayers or even portraits, monochromatic images are better because by deciding on your colours you will be taking the first step toward making the subject your own. You won't, in fact, have to invent that much in terms of colour, because a monochrome photograph conveys a surprising amount of information through tone alone. You can tell, for example, if clothing is white or a mid-tone, and whether skin is light, ruddy or dark. Also, because you can distinguish tone without being confused by colour, you can read form more clearly than in a colour photograph. If you are lucky enough to possess an old (out of copyright) family-portrait photo, you may find it interesting to create a painting from it.

Some colours are obvious, such as the sea and sand, but you will have to choose clothing colours based on depth of tone.

Colourful memories

Above Some posed family portraits can look a little stiff, so choose images of people in relaxed poses. This will give you a painting that is an interesting composition as well as a memento.

Unless your family portaits were taken by a professional in a studio, you will not have to worry about copyright issues.

Drawing for *painting*

- **Thumbnail sketches**
- **Working drawings**
- **Making the underdrawing**

When you have chosen your photo the next stage is to finalize your composition and draw it out on the working surface. If you are using just one photograph, or taking a detail from one, the composition will already have been decided, so you can draw it directly from the photograph, making any necessary adjustments as you

do so. If you are working from several photos (see page 50), however, you may need a further planning stage to decide the placing of the elements. You can plot out the composition by making a few quick sketches in pencil, trying out different arrangements until you are satisfied.

TRANSFERRING THE IMAGE

If the subject is complex, and your photographs and sketches don't give you enough information for the underdrawing, you can take the process a step further and make a working drawing. If this is the same size as the painting, you can simply trace it off using transfer paper, a kind of carbon paper (as for enlarged photocopies, as described on page 49). If it is smaller, you can either make a freehand underdrawing or use the squaring-up method (see opposite).

Reference photograph with area for the chosen compostion marked

Thumbnail sketches in a sketchbook

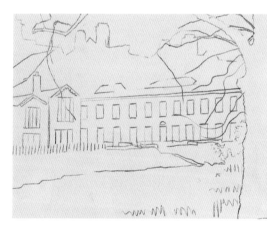

The image can be transferred from the working drawing to watercolour paper using transfer paper.

Planning your composition
Above The artist has worked from a single photo, finding several options. After doing some initial thumbnail sketches, she decided to use only the right-hand part of the photo for the composition (see working drawing, left).

Working drawing in pencil and ink

**See also: Combining photos (page 50)
Choosing the medium (page 58)**

Underdrawings for paintings in most media can be made in pencil, but don't use pencil under pastel because the graphite repels the soft pastel colour. Charcoal is a better choice, or pastel pencil. Many painters in oil and acrylic also use charcoal or draw with a brush and thinned paint.

The amount of detail you include in an underdrawing depends on the medium and the subject. In general, you need a more careful drawing for watercolours than for opaque media because you can't make major changes, but some landscapes may require no more than a few lines to place the main elements. For portraits and architectural subjects it is wise to make a thorough underdrawing to avoid having to make corrections as you paint. A good, solid foundation will enable you to paint freely and with more enjoyment.

PROJECTING THE IMAGE

Another way to make an underdrawing, and refine the composition as you do so, is to use a projector. This may sound like cheating, but is a method used by both professional artists and illustrators, who find that it gives both accurate drawing and the ability to play around with composition and to combine elements from several sources. For example, if you want to add a figure or some special feature to a landscape painting, draw out the landscape first and then simply project the other feature on top, moving it around and making it larger or smaller until you are happy with the composition.

The disadvantage of this method is the expense, and the fact that most projectors are made for slides only, which is why some artists make slides rather than prints. With the more basic models there can be a danger of damage to the slide, which may be burnt by the light if it remains

Another option is to make a freehand underdrawing, adapting the composition still further, as shown here in pencil and watercolour wash.

in the stop position for too long. If you are about to buy one, check this with the manufacturer or retailer. Some specialist art and graphic suppliers make a type of projector bright enough to shine through opaque materials, such as sketches or colour prints.

Squaring up

It is not easy to enlarge a photo or drawing accurately without distorting the proportions, but the squaring-up method ensures success. Although rather laborious, it is worth trying for such subjects as portraits or buildings, where proportions are of prime importance. The principle is simple: you draw a grid of small squares on the photo and another grid of larger squares on the working surface and transfer the information from one to the other. You will find it easier if you number the squares along the top and down one side, otherwise you can easily become confused. If you use this method for pastels, draw with charcoal or pastel pencil. For watercolours, erase the gridlines when the drawing is in place.

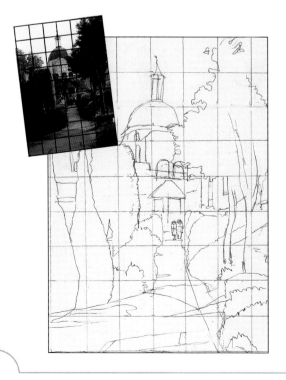

Choosing *the medium*

- **Trying out new media**
- **Pros and cons**
- **Tricks of the trade**

Some painters, whether amateur or professional, stick to just one medium, while others switch from one to another according to the subject or simply because they enjoy the variety. Although most subjects can be painted in any medium, you may sometimes look at a photograph and decide that you would do more justice to it by using an opaque medium, such as acrylic, than you would with transparent watercolours. You may want to stress linear qualities, in which case pastels would be good. The majority of amateur painters use watercolour, but since this is the most difficult of all the painting media, trying another may come as a welcome relief.

WATERCOLOUR

A good watercolour has a freshness and sparkle unrivalled by any other media, but this can quickly be lost by overworking and poor colour mixing. Two good general rules are, firstly, that you should not mix more than three colours – preferably two – and, secondly, that you should not lay more than three washes over one another. It is always best to achieve the right colour the first time, so if you are not confident about colour mixing practise on spare paper and make notes of successful mixtures.

You will need to make a more precise underdrawing (see page 56) for watercolours than for opaque media, because you can't make radical changes at the painting stage. Some correction is possible – if you find that you do need to alter an area, wash the paint off with a small sponge rather than trying to work over an existing colour.

Because watercolours are worked from light to dark, highlights must be reserved by painting around them.

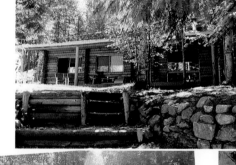

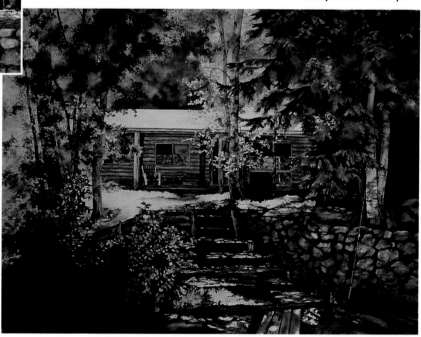

Brian's Place, **watercolour**
Cheryl Fortier-Campbell

Working with watercolour
Right The artist used wet-in-wet and wet-on-dry methods to acheive both soft effects and crisp detail. She has simplified the foliage but stressed the light streaming through it by increasing the tonal contrasts.

See also: Drawing for painting (page 56)

This is another potential cause of failure because, in trying to paint around a shape, your brushwork can become tight and fussy. This problem is easily solved by using masking fluid, which you paint over the highlight areas before laying on colour and then remove when the top colours are dry. Masking fluid is extremely useful for small or intricately shaped highlights.

ACRYLIC

Acrylic is the most versatile of all the painting media as you can dilute the paints with water and make thin, transparent washes, or use them thickly, straight from the tube, applied with bristle brushes, painting knives or even pieces of cardboard. You can also lay thin colour over thick – a technique known as glazing – which is a way of amending colours to make them either brighter or more muted. The great advantage of acrylics is that they dry very fast, so that you can make as many changes as you like while you work, painting out whole objects or adding others without the colours becoming dull and muddy. Acrylic is the only medium that allows for such drastic painting practices.

Some people dislike acrylics precisely because they dry so quickly, but you can extend the drying time by mixing the paint with a purpose-made, retarding medium. There are other mediums that you can buy that make the paint thicker (for knife-painting), more transparent (for glazing) and to give it a sheen – acrylics normally dry with a matt surface.

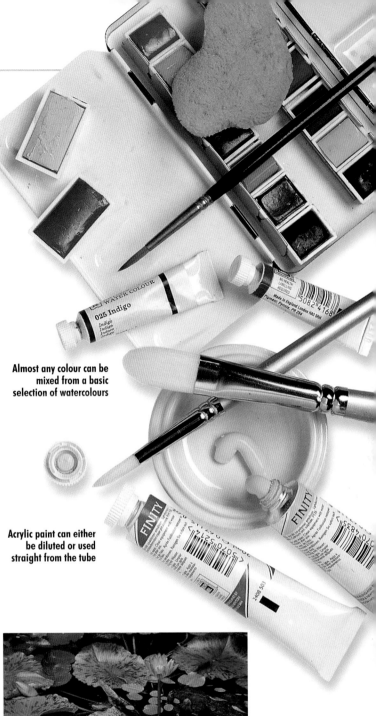

Almost any colour can be mixed from a basic selection of watercolours

Acrylic paint can either be diluted or used straight from the tube

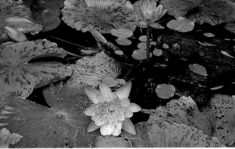

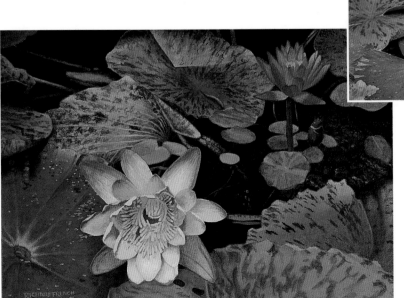

Watergarden Series – Lilies, **acrylic**
Richard French

Working with acrylic
Left Acrylic is suited to both fine, detailed work and rough, rugged approaches in which the marks of the brush play a vital role. Here the paint has been built up in a series of layers, with almost no visible brushmarks.

OIL

Oil paints also give you scope for correction, but not quite as much as acrylics. Oil paints are also opaque, which means that you can cover one colour with another, but if you overpaint too much while the paint is still wet you may stir up the colours and muddy them. It is usually better to scrape off the first colours with a palette knife and then rub down the area with a rag dipped in white spirit before applying new colour. Once the paint is dry you can overpaint safely, but you will have to wait at least 24 hours before doing so.

Oils have one major advantage over acrylics, however: because they are slow to dry you can blend colours together and move them around on the picture surface. The paint will remain workable for at least a day, and sometimes longer.

Adding a drying medium (top) to oil paints will speed up your painting process

You can apply oil paints with either brushes or a palette knife

Rue des Fleurs, oil
Betty Boyle

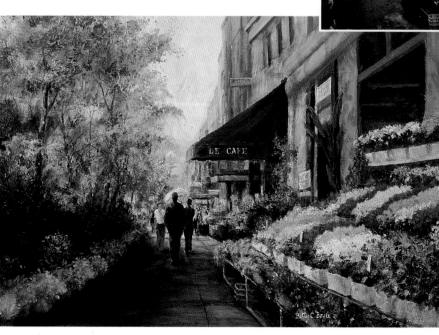

Working with oils

Left A great advantage of oils is that you can blend colours – the artist has made good use of soft blends in the foliage. She has used thick paint with decisive brushstrokes to help model the flowers and bring them forward.

PASTEL

Pastels are a good choice when making a first venture into a new medium. They are relatively easy to use, as they are so direct – when you use pastels you are drawing and painting at the same time. They also allow for a good deal of alteration and correction and you need no extra equipment except for paper and a can of fixative.

Some people are afraid of working in pastel because they have been told that you can't erase. This is true: you can never entirely remove a pastel line, but you can correct it simply by overworking, especially in the early stages. The trick is to lay on the first colours lightly so that they don't clog the grain of the paper. You can lay many subsequent layers on top, spraying the work with fixative if you find that a new colour is not adhering properly. Corrections are best made at an early or midway stage, but you can still make changes later if you have to. If the grain of the paper is fully filled, brush off the pastel colour with a bristle brush and then rub down the area gently with a rag before laying on the new colours.

Pastel sticks are available in an almost infinite variety of types and colours

Pastel pencils are useful for adding sharp detail

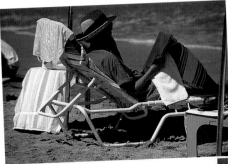

At Ease, pastel
Sally Strand

Working with pastels
Right Some artists exploit the soft, misty effects and gentle transitions obtained by blending pastel colours, but Sally Strand achieves her effects by layering colours. Each layer only partially covers the previous, creating shimering passages of broken colour.

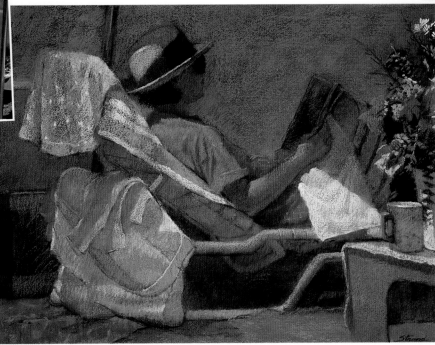

From photos to paintings

The following pages give you the opportunity of seeing artists in action, all working from photographs and producing exciting paintings in a variety of media and styles. Step-by-step demonstrations showing the method of eight selected artists are interspersed with examples of finished work, each accompanied by the photo used as the starting point.

Capturing natural *light effects*

EVOCATIVE TREATMENT OF LIGHT

Margaret Glass's landscape subjects vary widely, ranging from broad seascapes – often featuring yacht races – to architectural details and outdoor still lifes of everyday objects, such as a bicycle leaning against a wall. All her paintings are unified by one factor, however: they are all about light. Indeed it is always the light that draws her to a specific subject and prompts her to take photographs in preparation for painting. She has worked directly from life in the past, and sometimes still does, but she now paints increasingly from photographs as she finds the attention of bystanders at best a distraction and at worst a potential danger.

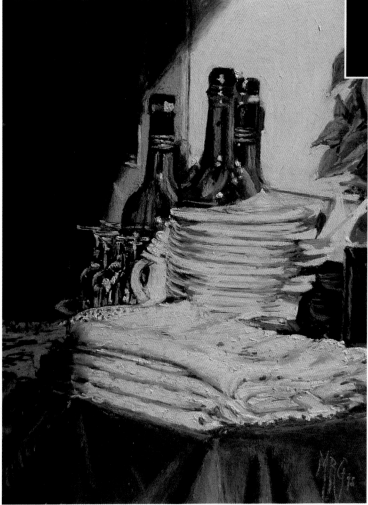

Awaiting the Guests, **pastel**
Left This is a perfect example of a 'found' still life – a subject that you just happen upon rather than set up deliberately. The photograph is far from perfect, but although the door on the left is very dark it provides sufficient information about the structure. Like the brushstrokes in the oil painting opposite, the pastel marks here are vital to the overall effect, giving a liveliness to the composition that is lacking in the photo. The artist has also used a much wider range of colours and tones than in the photo, and has suggested the texture of the linen in the foreground with heavily applied jabs of pastel that resemble impasto in oil or acrylic paintings.

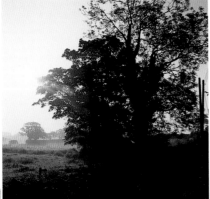

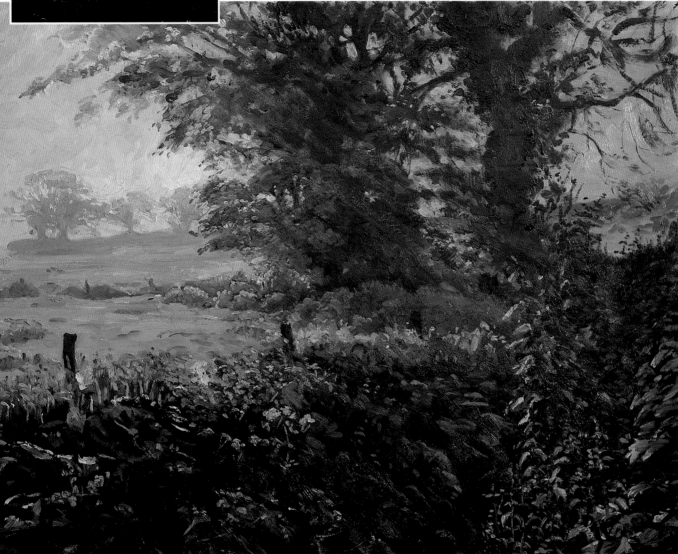

***Early Morning Walk,* oil**

Above Sometimes an accidental effect in a photograph can spark some ideas. Here the photo has been taken into the sunlight, causing a reflection on the lens, and this soft effect has been exploited in the oil painting. Because of the lighting conditions, only the distant areas in the photo are correctly exposed; the tree is unrealistically dark and the foreground largely unreadable, but the artist has been able to draw on her knowledge of this and similar subjects, to recreate these areas. Notice how she has used brushwork to give a sense of movement all over the painting, especially the sky, which is quite flat in the photo.

Café Tables in Seville
by *Margaret Glass*

- **Effects of light**
- **Taking extra photographs**
- **Making compositional choices**
- **Building up pastel colour**

The two photographs shown here were both taken for the same painting – while the artist hungrily waited for her lunch – but in the event only one was used. Her first idea was to combine the two to make a tall, upright painting, but she eventually decided that the brickwork and high window were less interesting than the tables and interplay of light and shadow behind them.

Format and Composition

The photographs are transparencies, not prints. The artist prefers these because the colour is usually better, and they are square – 5.6cm (2¼ inches) square – rather than the standard rectangle. She always uses the type of camera that produces square-format slides because she finds that this forces her to think more about the composition when she begins to paint. Instead of copying the painting's format and composition directly from the photograph (always a temptation when working from a print), she needs to find ways of turning the square into a rectangle, an approach which may lead to other compositional changes. In this case, the

composition has not been radically altered, and the rectangle has been achieved simply by focusing on the central section. As can be seen from the finished painting (above and page 69), she has had to draw on her memory and experience for the colours, because certain areas of the photographs are very dark.

Because the light reading was taken from the bright central area, the wall on the left is badly underexposed. The colours for it would therefore have to be invented.

The visual information contained here could have been used in a slightly different composition.

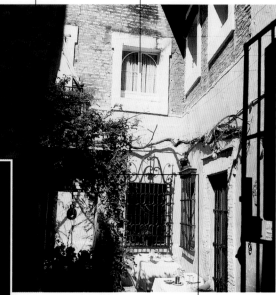

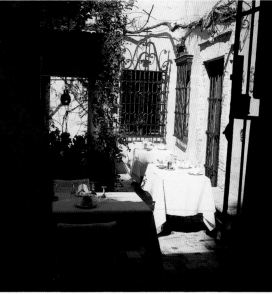

The window has been moved slightly to the right in the painting so that it stands clear of the foliage.

The chair and the front of the tablecloth are underexposed, with the result that all their colour has been lost. Notice how this area has been treated in the painting.

The light playing on the foliage is shown very clearly here, providing back-up information.

The blue tiles, which are barely visible in the photograph, become an important feature of the painting, contrasting excitingly with the deep red-browns.

1 *Working on artist's sandpaper, her preferred surface because it holds the pastel well, the artist begins with a very sketchy drawing in dark pastel. She does not attempt to make a precise rendering of the image, because she likes to let the painting develop mainly through the use of colour, making any necessary changes as she works.*

The placing of the tables, leading inward and up to the window, is the key to the composition.

Indicating the perspective lines is important, even at this early stage of the painting.

2 *The next step is to begin blocking in the colours and establishing the main areas of light and dark. Warm pinks and red-browns are contrasted with cool blue-greys.*

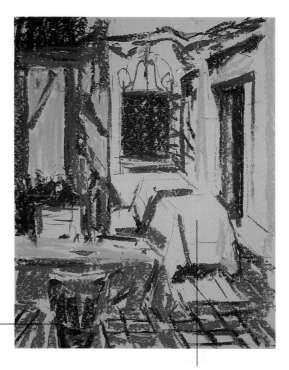

A near-black pastel is used on the chair; this will be modified with overlays of other colours later.

The paper is a pale sand colour, similar in tone to the light areas on the wall, so this area of the painting can be left uncovered for the time being.

Any mixing of pastel colors is done on the painting's surface. Light yellows and creams will be laid over this area.

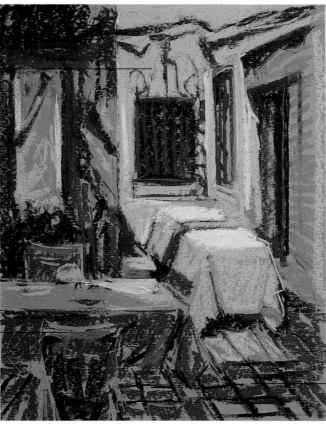

3 *The artist's method is to build up colours gradually, laying one over another to achieve a painterly effect. These strong pinks and yellows set the overall colour scheme, although they will continue to be refined and modified throughout the working process.*

The touches of blue on the chairs are important as they contrast with the warm pinks and yellows in the painting to continue the warm/cool colour interaction.

When using pastel it is best to work from the back to the front in order to avoid accidental smudging. This area will therefore be left until later.

4 *The colours have been built up quite thickly on the wall, foliage and tablecloths. The shadow cast by the grille has been drawn in firmly with the point of a red pastel stick.*

Notice how the same or similar colours are repeated from area to area in order to give unity to the composition.

The tone of this patch of sunlight is strengthened before any further work is done on the shadowed foreground. This will help the artist to decide on the correct tones to be used.

Café Tables in Seville
Margaret Glass

Right The artist made minor amendments and final touches until she was satisfied that all the areas of the picture worked together as a whole. The colour on the tiles in the foreground was softened by light blending, but this area was deliberately left loose, with patches of the paper colour showing between the pastel marks. An important final touch was to bring in a cool but rich blue-green on the leaves above the chair on the left, which balances the blue-grey on the door at the right and contrasts with the warm pinks of the wall and tablecloths.

5 *The painting is now nearing completion. The elegant wrought-iron grille has been drawn in with a sharp edge of pastel, the foreground colours have been blocked in and some lighter greens have been brought into the foliage to indicate where the leaves catch the light.*

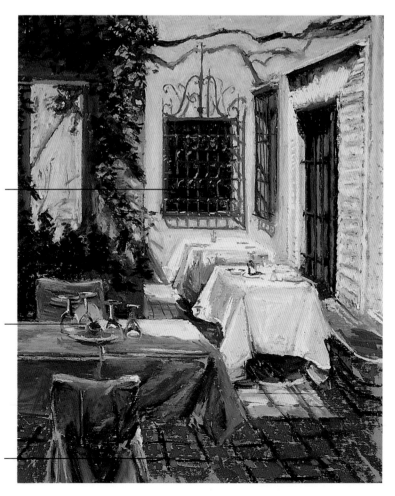

The grille is the focal point of the painting, and its shapes and structures are treated with care and precision.

The glasses on the table in the foreground and the objects on the other tables are treated broadly, described mainly by touches of well-placed highlight and shadow.

The small squares of blue on the ground echo the blues on the tablecloth and link the two areas together.

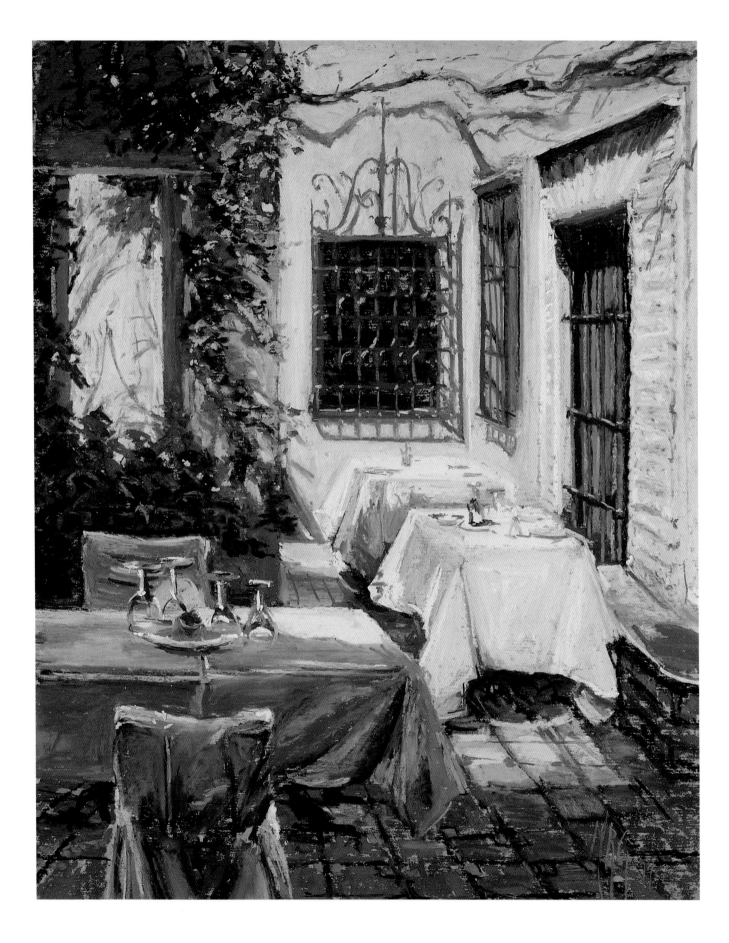

Artists' gallery: *still life*

Still lifes are most often painted direct from the subject, but there are several reasons why the camera can be a useful aid. You may have to set up a group in a place used for other purposes, such as a kitchen or living room, you may want to capture effects of light on a windowsill or in a garden, or you may see a ready-made still-life subject when out walking or on holiday. Also, looking through the camera viewfinder can help you to sort out your ideas, and thus form the first stage in planning the composition.

Mailboxes, **watercolour**
Joan I. Roche
Below This unusual painting could be described as urban landscape, but it fits equally well into the still-life category because it is a painting of static objects. Notice how the artist has edited the photograph, omitting the obtrusive parking sign and the white building on the left, and treating the other building as no more than a light suggestion.

**Peach Ice Cream, watercolour
Melanie Lacki**
Left Light is of the essence in this lovely painting. The group has been set up against a window so that the light comes from behind, creating bright rims on the objects and casting the shadows forward. The artist has exaggerated the light effects, using the photo only as an *aide-mémoire*, and she has also made important compositional changes.

**Seven Apples, watercolour
Kay Carnie**
Right The direction of the light was of vital importance in this composition. The sun was directly on the right, casting shadows that run parallel to the tabletop and link the apples to create a necklace effect. The artist has emphasized this dominant horizontal by placing the row of apples high up in the picture, with the verticals made by the folds of the cloth leading up to it.

Painting pattern *and detail*

USING BOLD COLOUR

Marjorie Collins is fascinated by rich colours, pattern and detail. In order to achieve her effects she plans her compositions with great care and builds up the colours slowly and deliberately, sometimes working on a painting over a series of days or even weeks. This careful approach is obviously not suited to on-the-spot work, so her first explorations of the subject are made with the camera, and she paints from her photographs rather than directly from life. Photographic reference is especially important for her still lifes, which frequently feature flowers or fruit, neither of which last indefinitely.

View from a Window, Chicago, watercolour
Above As in all her paintings, the artist has built up the watercolour slowly and methodically, working wet-on-dry and never allowing one colour to merge with another. The drawing and composition are taken directly from the photo, but the painting's colour scheme is very different, with the photograph's brilliant turquoise-blues replaced by sombre and more realistic mauve-greys. Notice, too, how the lights within the building are exaggerated so that they become bright rectangles of near-white, and how the distant area of road and lake is treated as a flat pattern, providing a light touch in contrast to the solemnity of the massive slabs of masonry and glass.

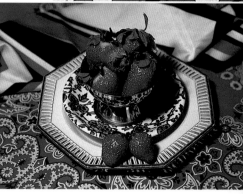

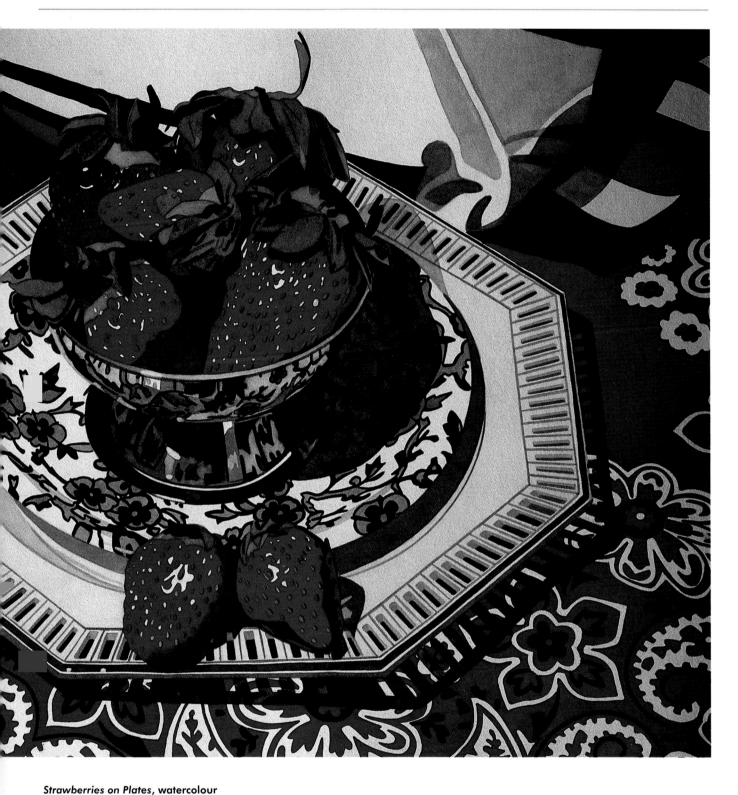

Strawberries on Plates, watercolour

Above The colour and detail in the source photograph are remarkable. However, the artist has made changes both at the planning stage and during the painting process. The composition has been cropped so that the striped cloths at the top and on the left side go out of the frame, focusing attention on the strawberries. The brilliant red in the photo has also been taken down slightly in hue and darkened in tone so that the white pattern makes a more positive tonal contrast. Reflections are important in much of her work, and she has made the most of the reflected pattern on the metallic surface of the bowl.

Rhododendrons and Pearls
by *Marjorie Collins*

- **Composing by projecting**
- **Establishing the tonal pattern**
- **Painting wet-on-dry**

For a still life, much of the composition is done at the initial, setting-up stage and the artist devotes a great deal of time to this preparatory process before she takes photographs. First she experiments with different combinations of objects and fabrics, and then she arranges the lighting so that it provides the shadows that she wants. Once she is satisfied with the general look of the still life, she uses the camera's viewfinder to explore different viewpoints and compositions, and then takes several photographs in order to give herself a variety of choices.

The Photographs
The photographs are taken with an SLR camera, the focal length she uses depending on the particular subject. For still lifes, she normally prefers a standard (50mm) lens in order to avoid distortion. She uses transparency (slide) rather than print film, partly because the colour is truer and the detail clearer and partly because she likes to project the slides onto paper. She considers this projection process a vital stage in planning the composition because she can increase or decrease the size of the objects, decide how to crop them or even combine elements taken from different transparencies. This composition was based on a combination of the two photographs illustrated here. If you compare these photographs with the finished painting (above and page 77), you will see that important changes were made at the projection stage.

The flowers are cropped in the painting so that they go out of the frame at the top and left side.

Both the vase and the mug have been increased in size and spaced more widely apart, without overlapping.

The leaf makes a better shape in the painting, provides a tonal contrast, and also makes a link between the vase and the mug.

The tone is lighter than in the other photo. The stripes have been simplified in the painting.

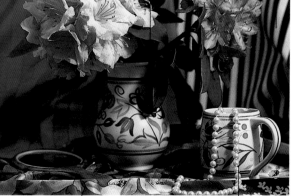

The mirror is omitted from the painting in order to give more emphasis to the main shapes and the patterned fabrics.

The leaf mass is confused and the objects are overlapping too much.

The horizontal fold in the fabric dissects the floral pattern to create a strong foreground.

The angle of the mug and the shape of the beads have been taken from this transparency, with the shadows more precisely defined in the painting.

1 *Working on medium-grain (Not-surface) paper, which she finds the best for detailed work, the artist first makes a careful line drawing from a projected image. She then paints in the shadows using a mixture of mauve and ultramarine. This method helps her to establish both the forms of the objects and the tonal pattern of the composition.*

When a further overlaid wash is required to strengthen the tone, as here, the first colour is left to dry fully beforehand.

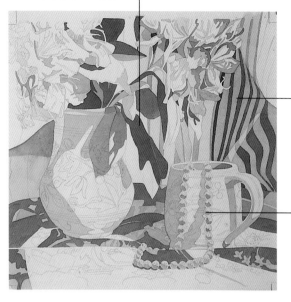

In order to 'grey' the shadows in the white areas, a very thin wash of yellow ochre is laid over the underpainting.

Care is taken to paint around the highlights, especially on the pearls.

These stripes are painted by alternating French ultramarine and Winsor green (a very vivid blue-green). In order to ensure purity of colour and crisp edges, each stripe is painted separately, with no overlapping.

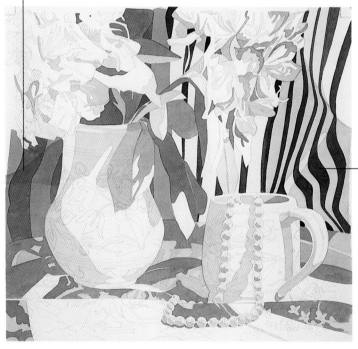

2 *The background is painted first, so that the vase and mug appear as negative shapes, light on dark. Painting the patterns on these objects will be left until a later stage.*

The dark stripes are painted with a mixture of black and French ultramarine.

3 *The patterned fabric is painted in several stages. A lighter version of the blue-black background colour is first taken around the flowers and left to dry. Then the flowers are painted, using various tones of alizarin crimson.*

Two tones of crimson are worked over one another, wet-on-dry.

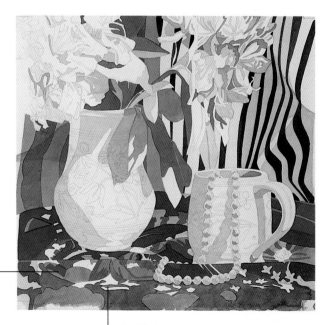

Blue-black paint is carefully taken around the edges of the leaf shapes and left to dry.

4 *The process of painting the cloth continues, with the leaves painted in sap green, and very light washes of rose madder laid over the left-hand flowers in order to intensify them. The artist uses pure colours whenever possible rather than making palette mixtures as overmixing can quickly muddy colours.*

The small white flowers in the cloth and the other patches of white are important to the tonal structure of the composition.

The centres of the flowers in the cloth are now painted in, using sepia and a touch of cadmium orange.

The paper is left white here, in order to ensure that the yellow-green remains pure and brilliant. Notice the tiny rim of white that defines the leaf's shape.

5 *The next step is painting the rhododendron leaves. The lighter leaves were left white, or only lightly coloured, at the underpainting stage, and these are now painted with the same green that was used for the leaves on the cloth.*

The colours will be intensified in the final painting stages, with more definition given to individual flowers.

The sap green that is laid over the mauve-blue underpainting results in a very subtle shade of deep grey-green.

6 *Now that the background and foreground colours are in place the patterns on the vase and mug can be painted. Aided by her precise and careful drawing, the artist paints each element of the patterns separately, using mainly the same colours as before, with the addition of Hooker's green, permanent magenta and two shades of yellow.*

Wherever colours are overlaid, the first is initially left to dry fully. Any running of colour would destroy the crisp effect.

Rhododendrons and Pearls
Marjorie Collins

Above The final stages of the painting process involved intensifying all the colours, darkening the pattern elements on the vase and mug and strengthening the shadows. The flowers were finished by adding various shades of rose madder to those on the left and permanent magenta to those on the right. These are two of the essential 'special' colours for flower painting, as they are both brilliant, pure hues that can't be produced by mixing the more standard colours.

Artists' gallery: *flower studies*

The main difficulty with painting cut flowers is that they change so rapidly, with buds bursting into flower and mature heads beginning to droop. While the flowers are still rooted in soil, growth is usually slower and less obvious, but here you will have to cope with the equally drastic effects of changing light. In two of the examples shown here, the flowers have been photographed outdoors in their natural habitat, allowing the artists to capture transient light and shadow patterns, while the third is a composite of indoor and outdoor shots.

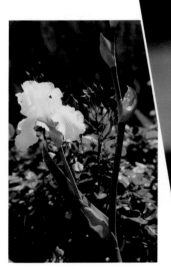

***Sunlit Iris,* watercolour**
Joan Hansen
Right The main photograph of the flowerhead, vital reference for the complex shapes, was taken indoors, but for the painting, the artist has chosen an outdoor setting, referring to the other photo for ideas on the background and additional elements. The shadow of the iris on the stone is an inspired touch, bringing in shapes and tonal contrasts that balance those of the flower.

**Cannas in Red,
watercolour
Kim Stanley Bonar**
Left This is another
example of how the
elements of a photograph
can be edited and
rearranged to make an
exciting composition. The
flower has been pushed
over to the left, and a
feature made of the dark
foliage which, together
with the large leaf
pushing upwards on the right, provides
a shape and tonal balance for the
brilliant red. The path and flowerbed
have been omitted in favour of an area
of flatly painted sky.

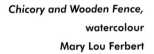

**Chicory and Wooden Fence,
watercolour
Mary Lou Ferbert**
Right Here too the shadow is
a vital element in the
composition, and the artist
had her camera at the ready
to capture it at just the right
moment. The photograph is
rather muddy in colour and
slightly out of focus, but it
has given her sufficient
reference to work from,
including a hint of the texture
of the wood, which she has
exploited in the painting.

Painting vivid *urban scenes*

THE CITY AT NIGHT

Michael Lawes is a painter of cityscapes, whose initial concern with topographical accuracy gradually gave way to an interest in visual effects, especially those of artificial light at dusk and night-time. He is fascinated by the way that streetlights and floodlighting superimpose their own colours on buildings, creating an artificial colour scheme that allows him to make colour the central theme of his paintings. He finds pastel the ideal medium for his intense effects. He originally turned to the medium only because it was faster to use than oil paints (allowing him to produce more paintings for exhibition), but he quickly came to appreciate it for its own sake and now rates pastel as his favourite medium.

City Buses, pastel

Below In this painting the subject is reflections. He has used only a small portion of the photograph, bringing the two buses into close focus so that the composition is based on the interaction of the verticals, horizontals and shallow diagonals. The colour scheme is loosely based on the photograph, but with heightened colour; compare the greys in the photograph with the rich red-browns on the left-hand bus.

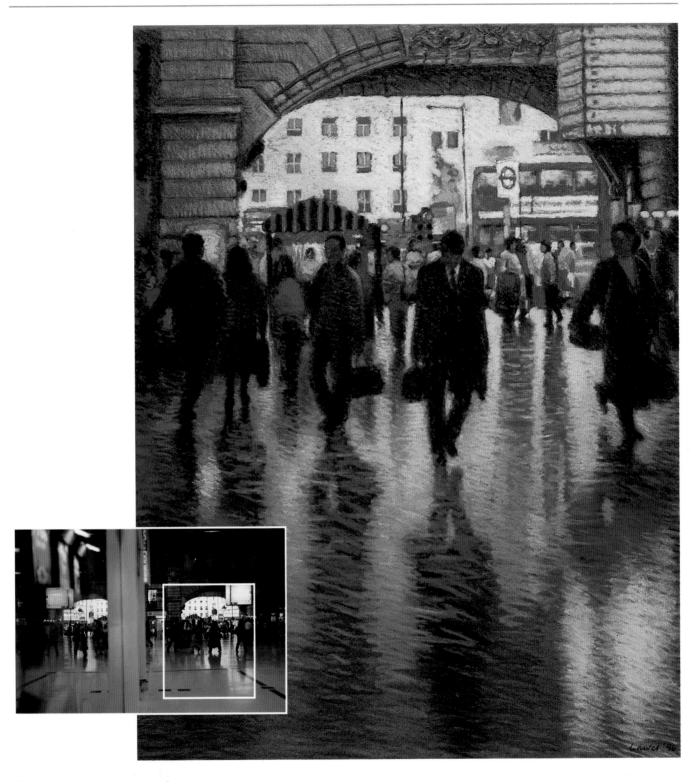

Victoria Station Entrance, pastel

Above This is an interesting example of how a dull photograph can be translated into something entirely different. The photograph does not make an interesting composition; it is also out of focus and the colours are drab. But by cropping the image and inventing his own colours the artist has created an exciting and colourful composition, in which the curve of the arch provides a counterpoint to the verticals of the walls and figures. His treatment of the noticeboard at top right is especially interesting. It looks unsightly in the photograph, and could have been omitted in the painting, but instead he has given it a major role through his choice of a brilliant turquoise colour, which is picked up in the reflection.

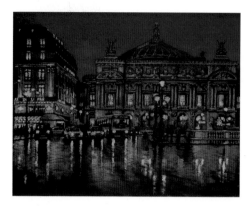

The Paris Opera at Night
by *Michael Lawes*

- **Making a personal statement**
- **Heightening colours**
- **Squaring up the image**

Sketching in city centres at night is difficult because there is seldom enough light to see by, and in many areas it may also be unsafe. Lawes therefore bases his paintings on photographs taken with a hand-held SLR camera and a very fast film (an 800 ASA colour-print film). A tripod would be needed for a slower film, or there would be a danger of camera shake. He takes a large number of photographs because he has found that a whole roll of film may only result in one or two paintings, often with elements combined from several images.

The Artist's Method
Lawes regards photographs as no more than an *aide-memoire*. He is not concerned with producing a faithful representation of the scene, preferring to develop the painting in his own way once he is past the initial planning and drawing stages. His first step is to make an enlarged colour photocopy of the photograph, cropping out any unwanted parts with a window mount. He then draws any additional elements that he wants to include, such as figures or in this case a bus, on tracing paper, moves them around, and sticks them down when he is satisfied with their positions. Finally, the collage is covered with clear polythene, which is easier to see through than tracing paper, and squared up (see page 57), to make it ready to transfer to the painting surface.

No colour is visible here; compare these dark areas with the rich blues in the painting.

The building seen on the extreme left of the previous photograph has been cropped out to improve the composition.

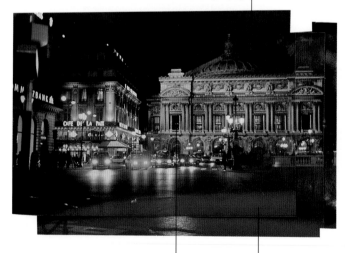

The windows are dark here, but in the painting the façade is brought to life by the addition of interior lighting.

In the painting, more space is given to the foreground and more emphasis is placed on the reflected lights.

The bus has been taken from another photograph of Paris and has been added to break up a line of similarly shaped vehicles and provide an accent of green.

The foreground has been extended by cutting and pasting in a strip from another photograph.

1 *The artist begins by transferring the image by means of the squaring-up method, using willow charcoal (pencil should never be used under pastel as the graphite is slightly greasy and repels the pastel colour). As he draws, he adds elements taken from other photographs.*

The statues had been removed from the building, leaving it looking incomplete (see photograph). They were drawn from a travel book which showed them in place.

The figures in the squared-up photograph were not clear, so they are taken from other sources.

Shadows are indicated at an early stage as they are important to the composition.

The green accents are put into the dome at early stage as this colour will be used again in the foreground.

The dark sky and brilliant yellow at left begin to establish the tonal balance of the picture.

2 *The surface used is pastel card, which is made from tiny particles of cork. This holds the pastel well and enables thick applications. The fairly dark, blue-grey colour of the card is helpful for assessing both the dark and light tones.*

The initial careful drawing enables a high degree of detail to be achieved at an early stage.

The pure-white colour used for the streetlight stands out strongly against the rich golds of the building.

3 *The artist's method is to start adding colour from the top then gradually working downward. This area will be left more or less as it is.*

4 *The building is now virtually complete. If you refer to the photo you can see how the artist is using his own judgement in respect of colour.*

The lit windows heighten the whole colour scheme and introduce an element of pattern that is absent from the photo.

Patches of blue, which are also missing from the photo, provide a colour link between the building and the sky.

5 *The buildings are completed first and now the artist turns his attention to the vehicles and their reflections. The blue-grey of the paper again helps in assessing the tones.*

The reflections are described with short, squiggly marks made with the tip of the pastel stick.

These accents of brilliant blue-green are repeated in several areas of the picture in order to unify the colour scheme.

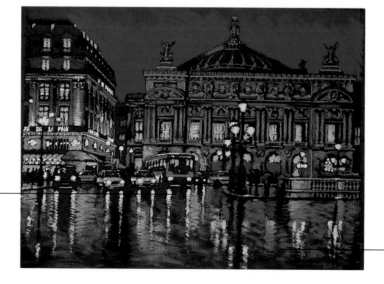

6 *The foreground is built up using short, horizontal strokes and shallow diagonals in various tones and colours, weaving in and out around the brightest reflections.*

Here again you can see the artist's use of repeated colours. The deep purplish-blue used for the sky reappears in the reflections.

Notice how the pastel strokes are largest in the immediate foreground and then become progressively smaller, creating the effect of perspective.

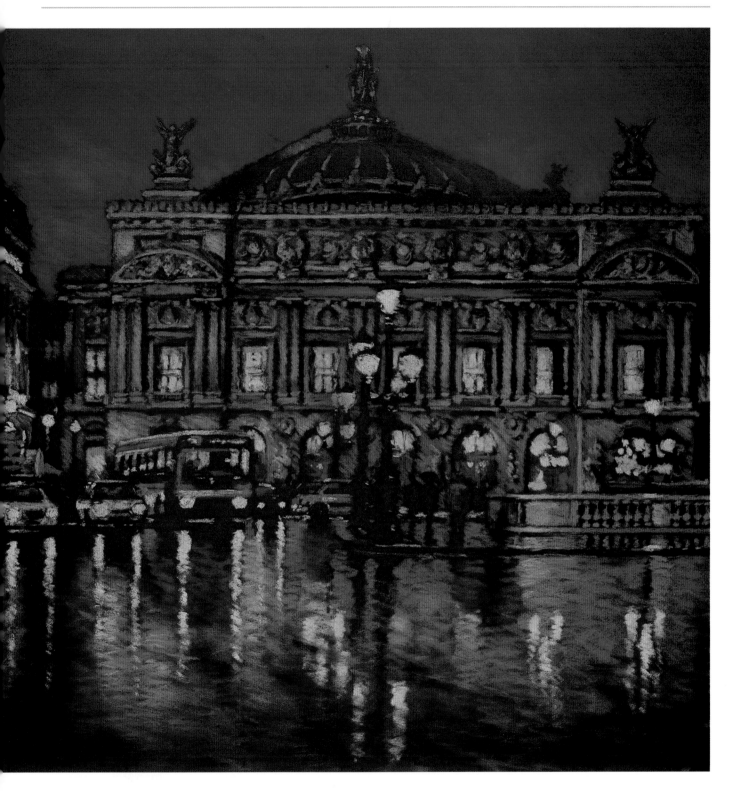

The Paris Opera at Night
Michael Lawes

Above Once the charcoal drawing was completely covered, the artist fine-tuned the picture. More depth was given to the sky with a light application of turquoise above the buildings. Parts of the façade were highlighted to give a variety of surface light. The blues in the reflections were modified, the vehicles checked for detail, and some backlighting from the oncoming vehicles was introduced to give a stronger impression of depth.

Artists' gallery: *painting buildings*

Architectural subjects demand a high standard of drawing, as the perspective and proportions must be correct. This preliminary stage can take a long time, perhaps over half of a painting session, so many artists prefer to work from photographs, which not only provide structural information but can also record short-lived light effects.

Santorini, **watercolour and collage**
Donald Stoltenberg

Above At the same time as taking the photograph, the artist made a colour sketch in pastel. This was a wise precaution, as the sea and island are very dark in the photograph due to under-exposure. The composition in the finished work is much stronger than in the photo or sketch, with the island simplified to a geometric shape and the ship making a diagonal that balances that of the top of the wall.

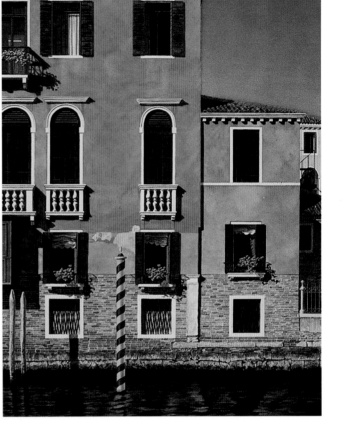

Venice Water Street, watercolour
Kay Carnie

Right Two photographs were taken for this painting, as the artist
had not fully decided on the format and how much she would
include on the left-hand side. In the event, she has cropped out
the confused area on the right, brought in an additional
mooring post on the left and reduced the area of water.

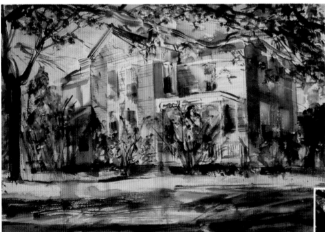

Oxford Series, watercolour, inks and wax resist
Alex McKibbin

Above This painting of a house in Oxford, Ohio, is one of
a series done from the same photographic reference – a
collage made by joining seven separate shots. The artist
has moved away from strict reality, introducing warm
colours onto the building and echoing the reds of the
shrub in the foreground and on the trees. His bold
brushwork, combined with the heightened colour, give a
lively sparkle to the scene.

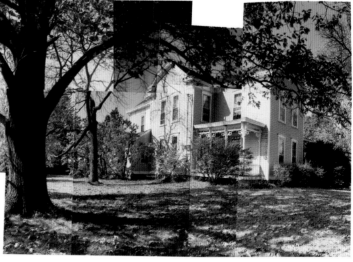

Colour and pattern *in landscape*

PERSONAL INTERPETATIONS OF COLOUR

Peter Welton is a landscape painter, but he prefers to describe himself as a colourist: he is more interested in exploring the interactions of colour on paper than he is in the actual colours of an observed subject. Although his paintings are based on the real world, he has his own agenda for the way in which he interprets a subject, so although he frequently sketches on the spot, he paints exclusively in the studio, using either sketches or photographs for reference. His watercolour method is also unsuited to outdoor painting, as he works flat, at a table, and builds up his effects slowly in a series of carefully planned stages.

Portmeirion, **watercolour**

Right The photograph has provided the format and basic composition for this painting, as well as valuable information on the statue and architecture. Important changes have been made, however, apart from the obvious one – the editing out of the group of people. The position of the statue has been altered slightly in order to make more of the sweeping curve of the balustrade; the formless mass of foliage below the buildings has been clarified and translated as a series of distinct shapes in varying tones and colours; and, most importantly, a striped pattern has been introduced to the grass on the left. This is a brilliant touch that pulls the whole picture together, with the horizontals counterpointing to the verticals of the statue and the tall, thin tower.

Channel Islands Ferry, **watercolour**

Right The photograph has been used for reference but the emphasis is on colour and pattern, and much of the painting has been created from memory and sketches. Changes have been made to the boat, which has become a chunkier but taller shape in the painting, with the stern sloping at a sharper angle. No use has been made of the sky from the photograph; instead, small, light clouds have been suggested with calligraphic brushmarks that echo the patterns of the water and foliage. The painting has been worked wet-on-dry in a series of stages, with each colour kept separate and highlights reserved by painting carefully around them.

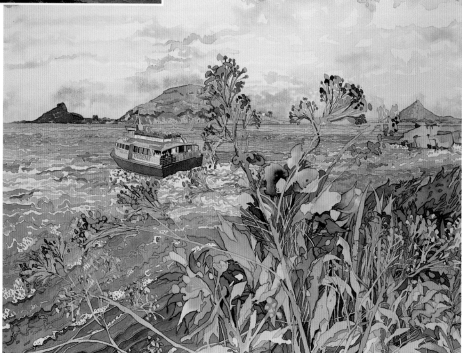

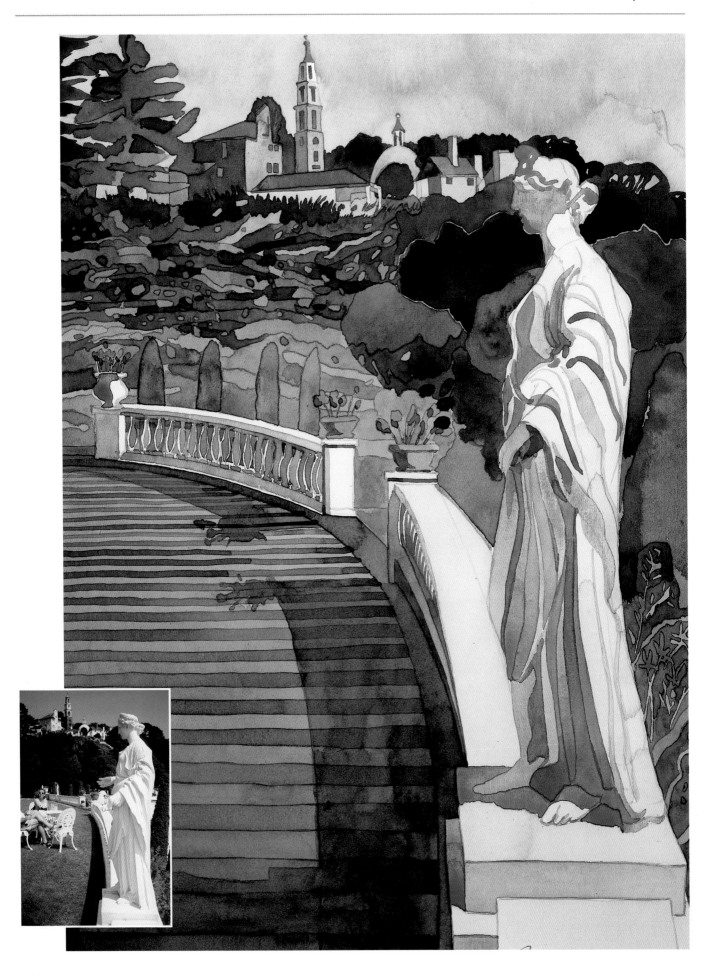

Boat Under Weeping Willow
by Peter Welton

- **Combining two photographs**
- **Exploiting the effects of light**
- **Working wet-on-dry**

The painting is of Giverny, the famous garden created by the French Impressionist painter Claude Monet, which is now open to the public and attracts artists and art lovers from all over the world. Because the garden is quite crowded it is not the ideal painting or sketching place for anyone who likes to work in privacy, so Welton preferred to base his painting on photographs.

The Photographs

The painting is loosely based on a combination of the two photographs shown here (which were taken with an automatic zoom-lens camera), but with a composition and colour scheme of the artist's own devising. It is interesting to compare the photos with the painting to see how he has used some of the features in the photographs and ignored or simplified others, drawing on his memory and past experience for certain areas of the composition.

The downward sweep of the willow branches is vital to the composition of the painting, but the artist has adapted the branches and leaves to form a decorative frame for the boat.

This dark area of shadow, simplified in shape in the painting, provides a tonal contrast to the pale leaves.

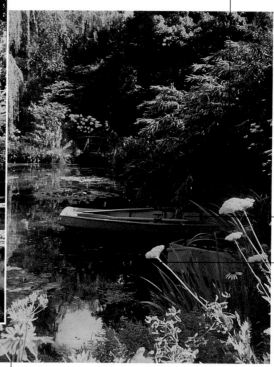

Only one boat has been used in the painting, which has been treated in a semi-abstract way, and with additional colour introduced.

The idea of the tall flowers leaning into the centre of the picture has been exploited in the painting, with more flowers and leaves added.

The water is lighter and less sombre in tone than in the other photo, providing ideas for the overall colour scheme of the painting.

This just-visible flower has been included in the painting, together with other invented flowers and leaves.

1 *The artist is working on stretched, medium-grain (Not-surface) paper. Stretching is essential as he uses a good deal of water in the early stages of the painting and unstretched paper could buckle. He makes no preliminary drawing and begins with a whisper of colour to establish the paler tones.*

The pale leaves were dried with a hairdrier before the darker greens were added.

Each leaf is painted with just one or two brushstrokes, with the paint taken carefully around the yellow flower shapes.

Notice the variety of colours in the leaves, achieved by using alizarin crimson both pure and in mixtures with Winsor green and lemon yellow.

2 *The artist continues to build up the leaves, using the hairdrier to prevent any running where one colour touches another. Most of the top part of the picture is painted upside down as this helps to achieve the points on the leaves – the mark made by a pointed brush is narrower at the top than at the bottom.*

The calligraphic brushwork is a feature of the painting, with the shapes of the strokes varied in order to describe the objects.

3 *In the earlier stages of the painting the photographs were barely used because they provided little helpful reference for the leaf shapes. The artist refers to them now, however, as he needs to understand the construction of the boat.*

The artist's control of the paint is remarkable: the green colour of the boat has been taken around the leaf shapes without any of the edges becoming spoiled or blurred.

The boat is simplified into a geometric shape, with such details as the oars omitted.

A suggestion of sky has been added and more leaves have been painted closer together to give the impression of a dense mass of foliage.

4 *The boat and foliage are developed further before the water and the darkest tones are painted. Red stripes are painted on the boat in order to make a complementary contrast to the green, drawing the eye to this focal point of the picture.*

When the green of the boat was painted the horizontal stripes were left as white paper so that the red would not be polluted by an undercolour.

Boat Under Weeping Willow
Peter Welton

Right The foliage at the top of the picture was completed with washes and brushstrokes of lemon yellow and viridian to give the effect of sunlight streaming through it. Then the dark tones were introduced, the details of the boat were added, more foreground flowers and leaves were painted in and the colours and tones were gradually strengthened and adjusted by means of thin, very wet glazes. The artist was concerned to include a full range of tones, from the white of the paper – always the starting point for a watercolour – to near-black (in this case a mixture of Prussian blue, viridian and alizarin crimson). In technical terms, what is remarkable about the painting is that no masking fluid was used: each highlight was reserved by painting carefully around it, yet each pale shape is perfectly formed and every edge is clear and sharp. Not surprisingly, the painting took several days to complete.

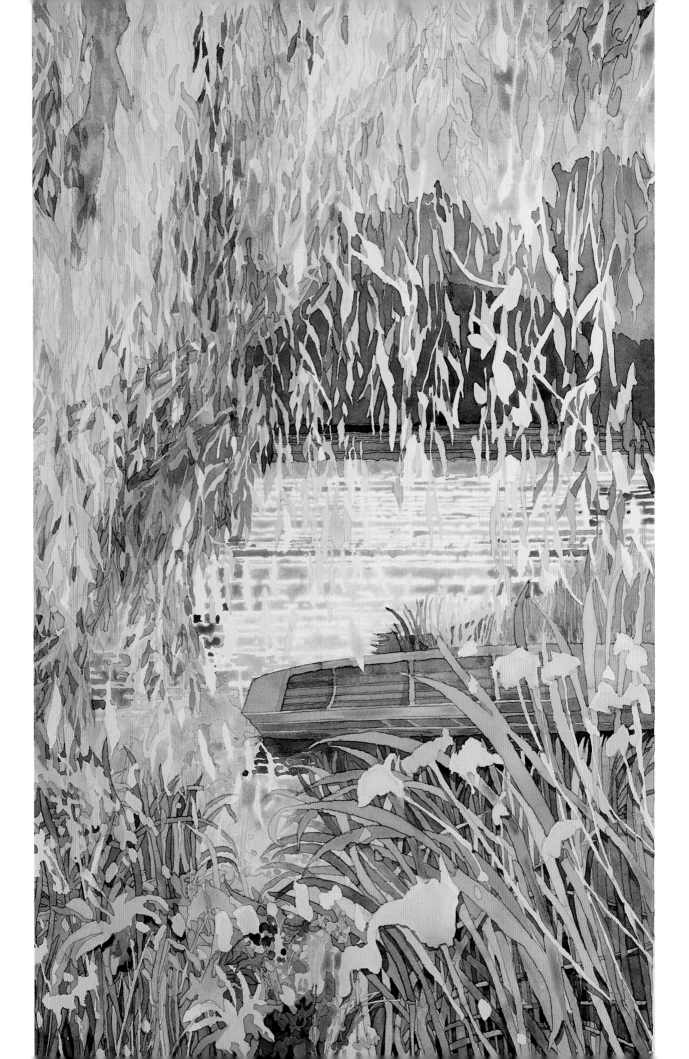

Artists' gallery: *flowers and foliage*

The eye is always drawn to colour, and because the brilliance of flowers is so seductive we tend to give less thought to foliage and to treat it simply as an area of green. But leaves and stems, although less 'high-profile' than flowers, are often exciting in shape and colour, and foliage can make a subject in its own right.

***Poppies,* oil**
Jan T. Bass
Right Although the photograph does not show the foliage clearly, the artist has given it as much importance as the flowers, using the subtle grey-greens as a foil for the vivid yellows of the poppies. Compare the photo with the painting and you can see how much she has changed the composition, using a vertical rather than horizontal format and rearranging the flowers so that they form a diagonal from right to left.

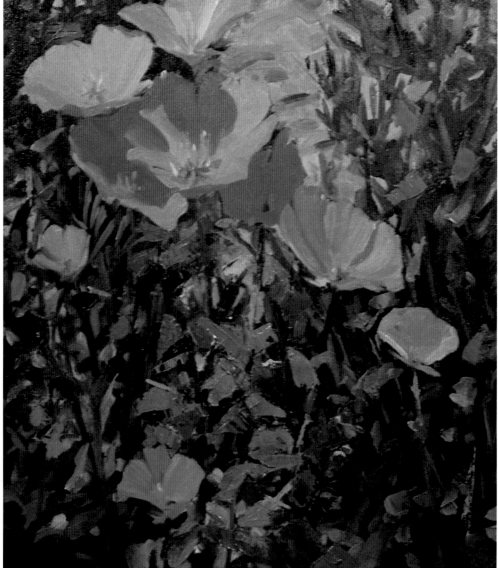

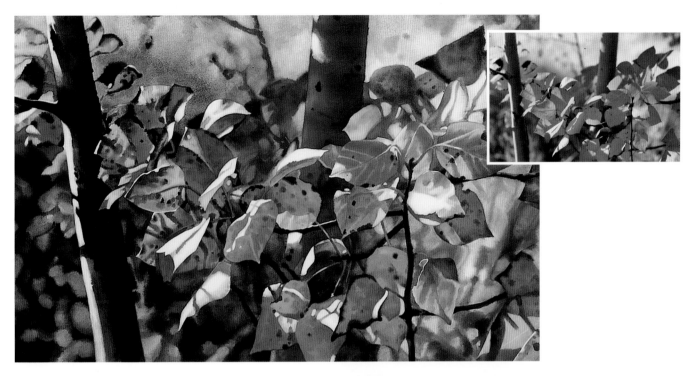

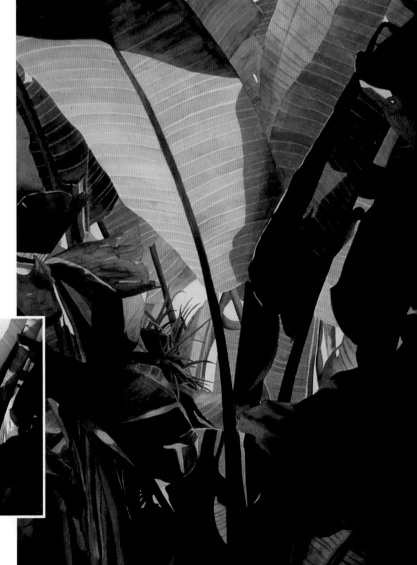

Blue Aspen, watercolour

Karen Frey

Above A sure hand and considerable technical skill were
needed for this subject. The artist has contrasted careful
wet-on-dry work on the foreground with wet-in-wet
behind the tree trunks, thus creating a soft-focus effect
that pushes the background back in space. To emphasize
the leaves, she has given them crisp edges and distinct
veining, and she has warmed the colours to create an
autumnal atmosphere.

Afternoon Light, watercolour

Kim Stanley Bonar

Right This large-leaved plant would
be an exciting subject in itself, but
here the sunlight shining through
the leaves adds an extra element,
providing a dramatic composition
based on tonal contrast and strong
shapes. The photograph is
underexposed in places and
overexposed in others, but the
artist has used this effect, only
slightly darkening the tone of the
main leaf and enriching its colour.

Composing from *multiple images*

CREATIVE COMPOSITIONS

Christine Russell is primarily a painter of still lifes, whose work in this genre is much in demand, but she also paints landscapes from time to time, enjoying the challenge of a different subject. Her still lifes are painted from life, but for practical reasons she uses photographs for landscape painting. She sometimes begins a painting on the spot, or else makes sketches, taking photographs with a small automatic camera as a back-up so that she can finish the work in the studio. If time is too limited for sketching, she works entirely from photos, often incorporating elements from several shots of the same scene.

Testing the Water, **pastel**
Below In this painting, Christine Russell employed a large measure of artistic license, with the colour and tonal values considerably heightened. The brilliant orange used for the foregrounds and clouds, for example, does not appear in any of the photos. She added figures to inject some dynamism into the picture and give it a sense of scale, and the way they are backlit, emphasizes their importance within the composition.

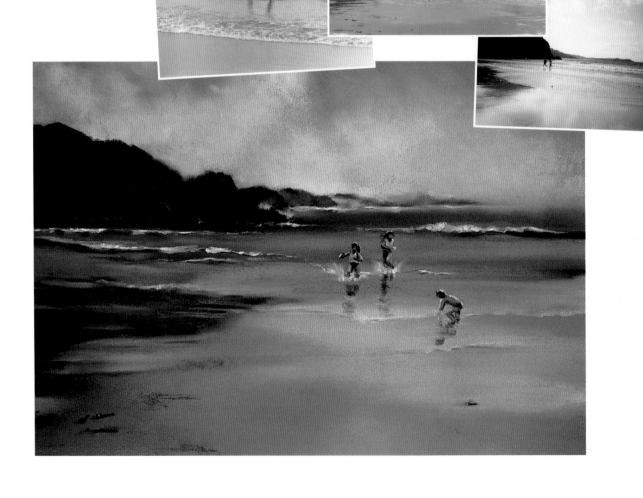

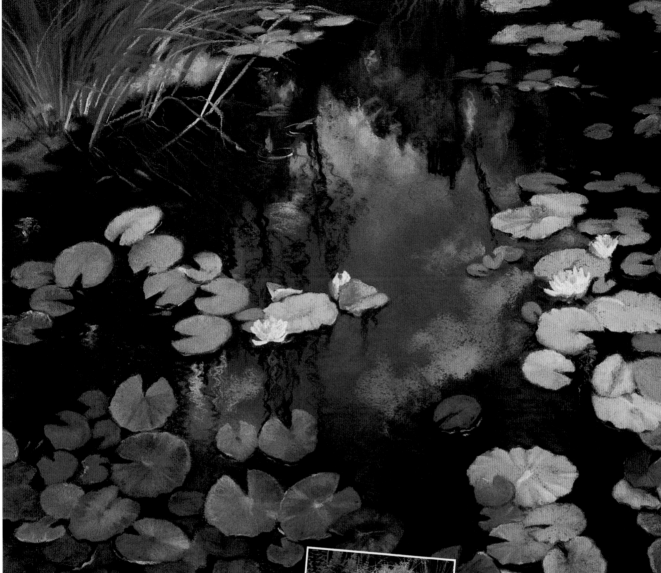

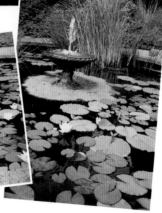

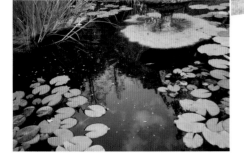

Waterlilies, pastel

Above Three photographs provided
information for this delightful painting,
but its success owes as much to what
has been left out as to what has been
included. The stone fountain figures
prominently in all the photos, and in the
upright one it seems to make a natural
focal point, but the artist preferred to
omit it, focusing instead on the water in
order to convey a sense of
contemplation and mystery. To make
a stronger composition, she has
heightened the tonal contrasts so that
the leaves and flowers, and the tiny,
darting shapes of the fish, stand out
against the dark water.

Maltese Luzzu
By Christine Russell

- **Making a planning sketch**
- **Working methodically**
- **Controlling the colours**

The artist was attracted to the riot of colours in this Maltese harbour scene, and because it was vital to have an accurate reference for both the colours and the details of the boats and buildings, she took a number of photos, always a wise precaution when painting the subject from memory. The central concept of the composition – the shapes made by the three central boats and their reflections – was taken from one photo, with various extra details brought in from others.

The artist first made a pencil sketch in order to establish the positions of the *luzzu* (fishing boats) and background landscape. The boats were then rearranged to suit the composition, and to avoid confusion at the painting stage, the sketch and photographs were all numbered. The background details were also taken from several photos.

The church and tree were taken from photograph E.

The three central boats were taken from photograph A.

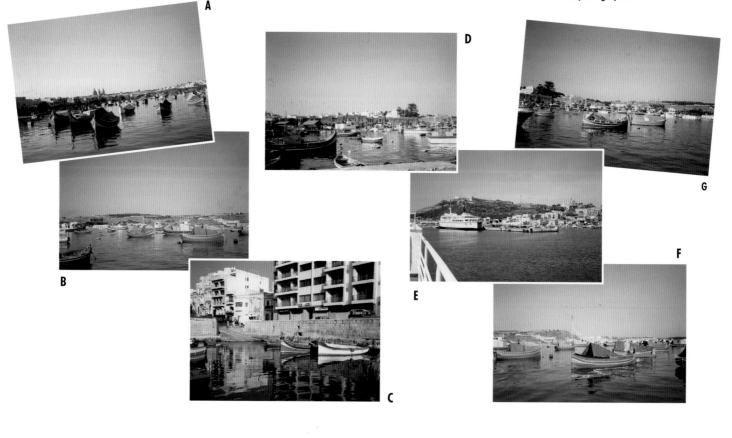

The sky is put in as soon as the drawing is complete, using the sides of pastel sticks.

1 *The artist is working in soft pastel on a burnt orange Mi-Teintes paper. She has chosen this colour because it will show through the pastel in places, helping to unify the picture and give an overall feeling of warmth.*

The drawing is made with pale pink pastel pencil, which shows up well on the mid-toned paper.

The paper is covered only very lightly here; the building is described mainly by its windows.

Attention is paid to the direction of the light, which comes from the left.

2 *The artist works from the top of the picture downward, the practice of many pastel painters as it avoids the danger of smudging with the hand. She paints the shapes of the buildings with care but deliberately loosely, letting the paper show through the pastel, because she does not want this area becoming too 'busy'.*

The red stripes on the boats must be seen as being red, but must be less vivid than the reds in the foreground.

Here the colours are lightly scumbled over one another and allowed to merge. In some places, thin veils of pink and orange are laid on top.

3 *Now the distant boats are painted and an area of water is laid around them. The colours and tones are carefully controlled so that they do not become too vibrant, which would sacrifice the sense of depth and recession.*

The colours used for the water are taken carefully around the boats in order to keep the edges clean.

The crisp outlines are achieved by using the sharp edge of a pastel stick.

4 *The work continues on the middle distance, with more detail gradually built up on the boats and dark tones introduced.*

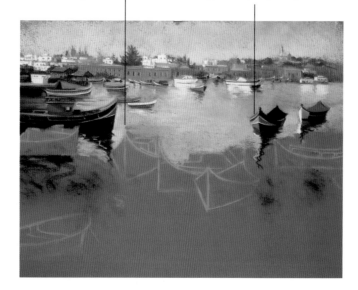

Notice the artist's careful control of tones here, with the solidly applied white standing out against the pale water.

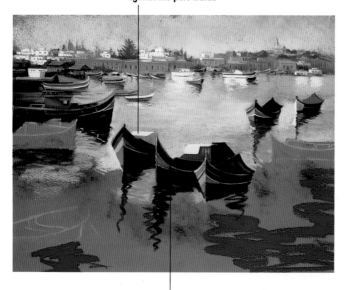

5 *The three main boats are now put in, and the artist begins to indicate the reflections beneath them by using long, squiggly strokes made with a blunted pastel tip.*

The sharp edges have been achieved by previously leaving the paper uncovered. When there is a build-up of colour the paper becomes clogged and the edges become more blurred.

Care is taken not to lose the quality of the water, and the feeling of movement, by working too tightly. The colours are loosely scumbled onto the paper and the reflections are indicated with calligraphic marks.

The green and the turquoise are close in tone, but the green is a much warmer colour and thus stands out more.

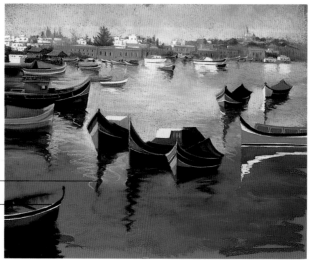

6 *The front of the picture has now been reached, and the paper almost entirely covered. The green of the rowing boat is carefully judged against the turquoise of the water.*

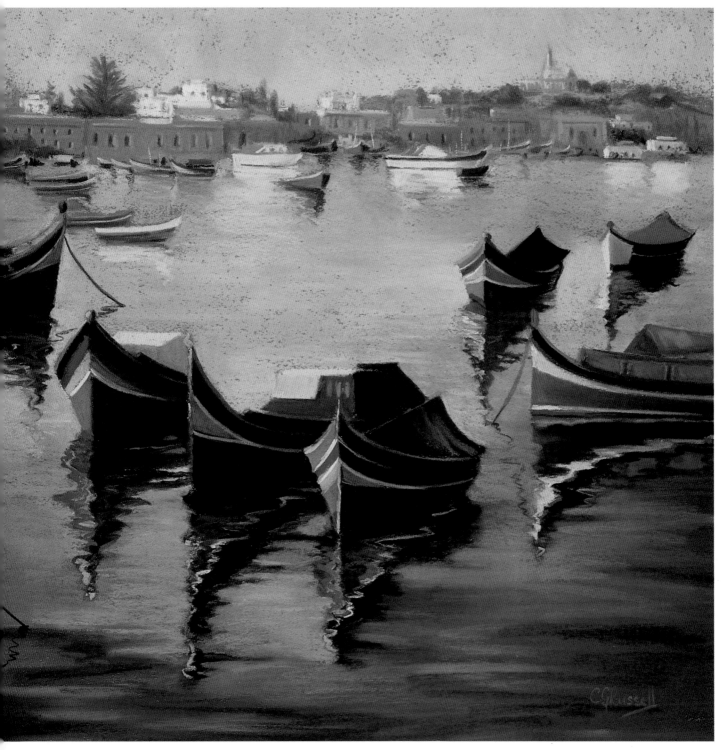

Maltese Luzzu
Christine Russell

Above In the final stages of the painting the artist really enjoyed herself with the reflections. She made a series of quite loose, wiggly lines, but at the same time took care to preserve the overall shapes, which are vital to the composition. More colours were scumbled onto the water and the rowing boat was completed, but this was kept understated in order not to compete with the focal point. Final adjustments were made all over the painting, the drawing and colours of the central boats were sharpened, and deeper, richer colours were brought into the foreground water to give the illusion of bringing it forward in space.

Artists' gallery: *focusing on details*

If you begin to focus in on small details of a subject you may find a new world of painting possibilities opening up. In towns and cities, windows, balconies or old steps can make exciting and unusual subjects, and in landscape, stiles, stone walls and gates are just a few of the many possibilities. But such paintings can become dull unless you look for special qualities such as texture, pattern, or the play of light and shade on a surface.

***Old Door*, watercolour**
Mary Lou Ferbert
Right The artist was sure at the photography stage where her interests lay; all she wanted was the door, and to give herself sufficient information about texture and colour she took three shots, panning up and down. She has wisely omitted the date above the door, as this might have taken attention from the letterbox, which is the focal point, and she has played down the shadow in order to stress the strong upright rectangle.

Pillars, **watercolour**
Cheryl Fortier-Campbell
Right Taken as a whole, the photograph does not make a particularly exciting subject, but the artist has seen its potential for a composition with a strong vertical emphasis and good tonal contrast. The brickwork provides a vital touch of colour, and the texture of the whitewashed rendering has been skillfully suggested by touches of wet-in-wet painting.

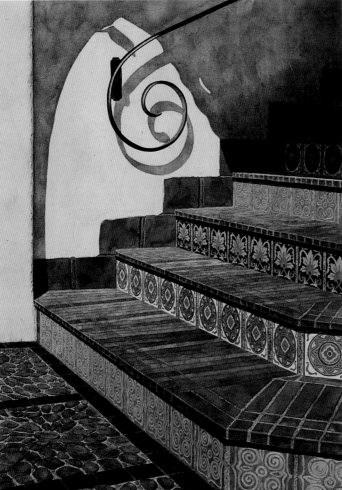

Tile Steps on Ramona Street, **watercolour**
Kay Carnie
Left The impact of this painting stems equally from the colours and the interplay of diagonals and curves, with the steps leading in to the patch of sunlight and the elegant curl of the banister rail. The sunlight on the wall forms a pointed-arch shape that reinforces the oriental feel of the picture, and it was especially important to capture this with the camera; the other photo was used only as reference for the patterns.

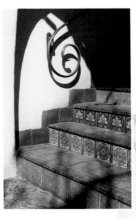

A personal response *to architecture*

CONTROLLING COLOURS AND TONES

Annie Penney came to painting through slightly unusual routes: having worked as a cartographic draughtsman, she then studied fashion and textile design at art college, and after leaving became first a knitwear designer and then a graphic designer. It was her first experience of photographs taken with a zoom-lens camera that gave her the desire to paint, and she still uses photographs as the sources for her paintings. The camera allows her to respond immediately to an image that excites her, and to gather a lot of material in a short space of time. She always works in watercolour, using a very small palette of colours. Her experience of textile printing gives her a sound knowledge of colour theory, and she finds that she can mix most of the colour ranges that she requires from only the three primary colours.

Lunchtime in Nadeul, Tunisia, **watercolour**
Right However shallow the space, it is important to create a sense of depth, and this has been achieved through perspective and tonal contrast. The shadows explain the spatial relationships, with the figures and jutting platform on the nearest plane, slightly in front of the façade. The shadows in the photograph are probably darker than they were in reality, but the artist has not tried to modify them because the whole composition hinges on the stark light/dark contrast and the pattern this creates.

Sealed doorway, Sidi Bou Said, **watercolour**
Right Although the painting is a faithful reproduction of the photograph in terms of its composition and colour, the way in which the paint has been used gives it an extra dimension, with lovely, fluid washes transforming a static image into one that is full of life and vigour. The artist achieves her effects by mixing large quantities of paint, working with a well-loaded brush, and frequently removing paint in various ways – mainly by blotting the surface with tissue.

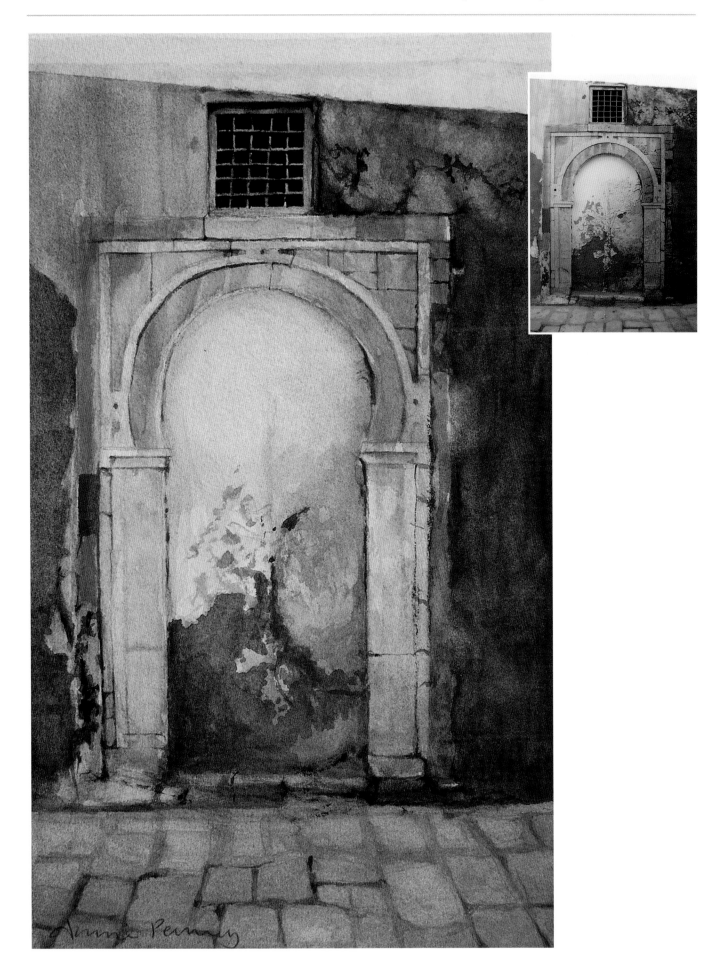

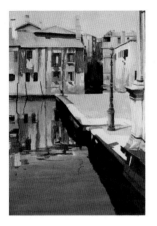

Blue Lagoon, Venice
By Annie Penney

- **Gathering material**
- **Composing with the camera**
- **Creative use of watercolour**

Annie Penney travels widely in search of her painting subjects, always taking photographs rather than sketching. Since her chosen subject is architecture, the locations that interest her are often busy thoroughfares in which it would be difficult to sketch. Apart from this, she dislikes the prospect of being engaged in conversation or otherwise disturbed. She uses an SLR camera with a zoom lens, and as soon as each film is processed she goes through a rigorous selection process, often using no more than two or three images from each film. Once she has chosen a photo, she makes only small changes to its composition and colour scheme, and often none at all. In this painting she omits some detail and alters the proportion of reflection to clear water.

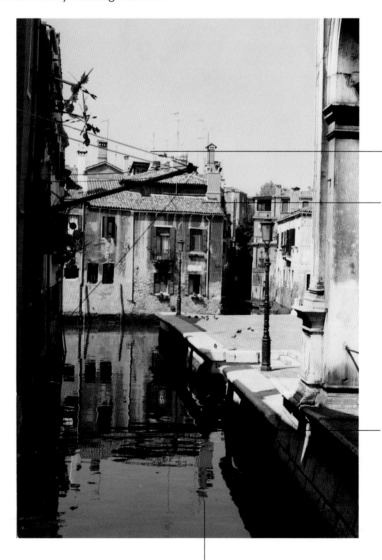

The cables are not helpful to the composition and have therefore been omitted in the painting.

The rooftops have been treated almost as flat colour in the painting, and painted in a paler tone. Too much detail here would deflect attention from the façade and reflection, the picture's focal point.

The shape of the dark reflection has been simplified in the painting so that it makes a stronger diagonal, leading the eye inward towards the buildings.

In the painting this blue area has been enlarged to give a greater sense of space, pushing the building and reflection back.

1 *The photograph is enlarged by eye, to a size that suits the amount of detail to be shown. The paper is a medium-grade (Not) surface, which is heavy enough not to require stretching. Instead, it is attached to the board with masking tape, which is applied at the top only.*

A light pencil drawing is followed by a pale wash for the sky, taken carefully around the rooftops.

The pale brown used for the base wash on the water area will give warmth to the blues laid on top later. The artist frequently mixes colour on the surface in this way.

The blue wash of the sky is allowed to dry before the roofs are painted.

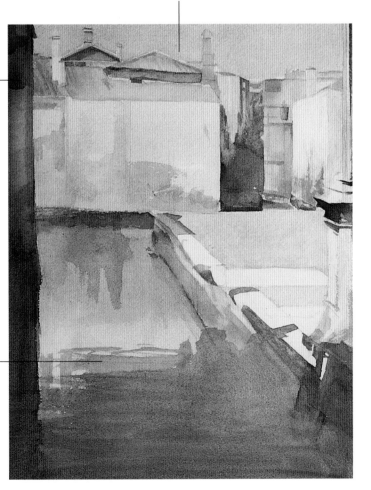

This dark upright shape balances the smaller rectangle of shadow between the buildings, so both areas are established at an early stage.

2 *Now the middle tones are introduced, still using broad washes. The artist works with a well-loaded brush, flooding on the colours and blotting off any surplus with soft tissue paper. At this stage she concentrates on the tonal pattern and balance of shapes.*

You can see the effect of surface mixing here, with ultramarine being laid over the pale brown wash. The brushstrokes are deliberately rough, suggesting ripples on the water's surface.

The roof tiles are described mainly by the corrugated pattern at the top of the shadow area, but directional brushstrokes give a further suggestion of texture.

3 *Working all over the picture simultaneously, the artist gradually strengthens the tones and colours, introduces the rich, red-browns on the façade of the building, and begins to indicate the details.*

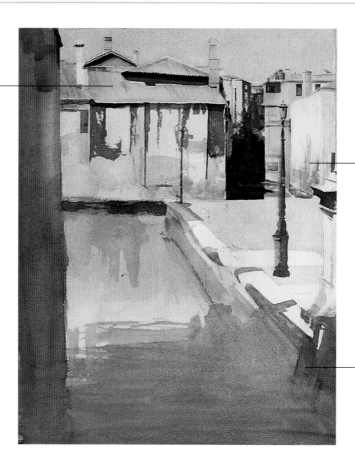

To suggest a rough texture, the brushmarks are 'broken' so that patches of the white paper show through.

This vivid colour will be modified slightly with further washes later, but it is important to bring the area forward in space.

4 *Apart from a light indication of tone and colour, the reflection of the building was left alone until this stage. With the main elements of the building established, the artist can now judge where best to place the key shapes and colours. The warm red-brown is repeated in the reflection, and the blue of the foreground water intensified.*

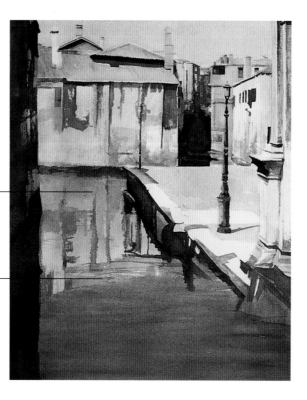

The reflection will not be completed until the details of the building are in place because the two subjects must be worked hand in hand.

The water is slightly disturbed so that the reflection is broken, most obviously at the bottom. Calligraphic marks made with the point of the brush suggest the movement of the water.

Blue Lagoon, Venice
Annie Penney
Right In the final stages of the painting the building and its reflection were completed, with care taken over the placing of each main feature of the reflection, such as the windows. The long, dark, diagonal reflection beneath the walkway was painted with a warm brownish mixture laid over the blue of the water, and a light suggestion of stonework was given in the immediate foreground by means of a few well-placed brush lines. Further washes were laid on the left-hand wall in order to darken the tone – notice how cleverly the windows have been suggested by reserving window-shaped patches in the lighter colour.

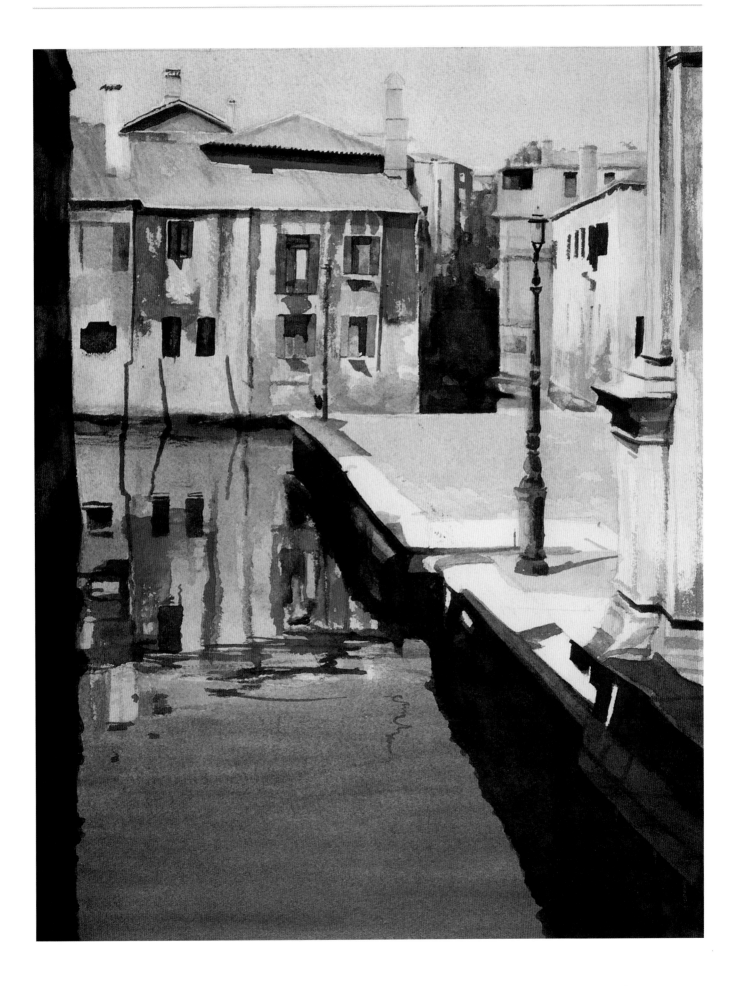

Artists' gallery: *painting seascapes*

One of the most interesting aspects of seascapes is the interaction between the water and any solid, static or man-made objects such as rocks, buildings and boats. The artists featured here have all explored this in different ways.

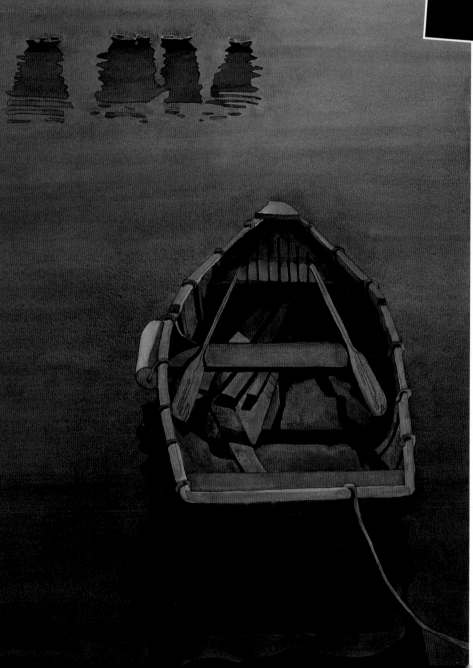

Orange Sea, **watercolour**
Willamarie Huelskamp
Left The artist had a definite agenda for the painting before she began, and took the photograph as no more than back up for the details of the boat, of which she also made a sketch. In the painting, colour and economy are the keynotes, and the cluttered background in the photo has been reduced to strong, simple shapes.

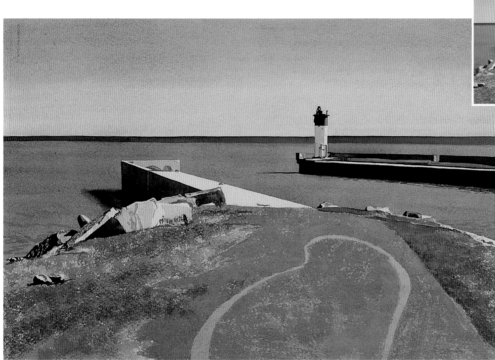

***Newcastle Lighthouse,*
watercolour**
Linda Kooluris Dobbs
Left Minor but very important
changes have been made to
both the composition and
colour scheme in the
painting. The format has
been changed to
accommodate the extra
height given to the
foreground, and the curve on
the right has been
strengthened so that it leads
in to the jutting masonry. The mauve-grey used
for the sky, replacing the blue in the photo,
echoes the foreground colour, pulling the
whole composition together.

***Weather Wind,*
watercolour and pastel**
Jan T. Bass
Right The artist has captured
the atmosphere of a windy
day at sea, using the dark,
solid shape of the boat as a
foil for the restless water, with
an additional sense of
urgency created by the figure
in the dinghy. Two photos
provided reference for the
details of the boats, but
important elements were also
drawn from memory and
prior observation.

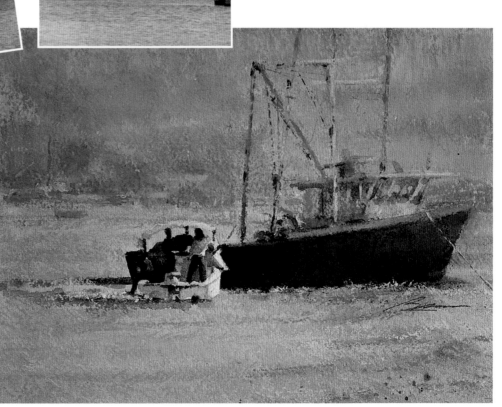

Colour and atmosphere *in* *land- and seascapes*

MAKING PICTORIAL DECISIONS

David Cuthbert's subjects cover a wide range, and he works in a variety of media, but he has recently concentrated on acrylic landscapes and seascapes. Although he paints on the spot when time and weather permit, a great many of his paintings are based on photographs, which he uses as a starting point for the compositions. His photos also act as an *aide-mémoire* for the atmosphere and overall feeling of the scenes, but he refers to them only occasionally when he works, usually to check shapes and structural details. The important decisions about colour and tone values are made in relation to the paintings themselves, which after the first stages are allowed to develop as independent entities.

Barrow Sands, acrylic

Below The photograph, taken with one of the inexpensive 'throwaway' cameras that takes panoramic shots, is dull in terms of colour, but has provided a potentially exciting composition based on wide sweeping curves. The artist has departed from the standard landscape rectangle and used the photograph's wide format for the painting, which works very well and makes the most of the subject. The colours have been heightened so that the rich browns and pinks contrast with the deep greens behind the foreshore to make a more positive statement, and the painting has been given additional interest by the use of texture. Prior to painting, a ground was laid by applying acrylic modelling paste with a knife, resulting in small raised marks and ridges that show through the paint.

***Estuary Mud, Topsham,* acrylic**
Above The bold and unusual
composition, with the focal point
placed high in the left-hand
corner, was decided when the
photograph was taken. Apart
from this the photo is unexciting, as the
painting might have been without the
heightened colour and addition of
foreground detail. In a basically
naturalistic landscape, it is important
that any major additions of colour make
sense in relation to the subject. Here the
artist has simply invented different light
conditions, imagining a clear blue sky
reflecting in the small pools and runnels
of water and casting a blue sheen on the
wet sand. The water has little or no
colour in the photograph, but it has
nevertheless provided useful reference
for the shapes of the pools, the
foreground stones and the piece of
weed in the centre.

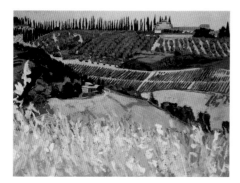

Landscape, Val d'Elsa
by David Cuthbert

• **Using complementary colours**
• **Simplifying shapes**
• **Creating space**

This scene – with the patterns made by the rows of planting on the light-coloured soil, the red-tiled buildings and spiky cypress trees – was an almost ready-made painting subject, and the artist took a photograph in order to recreate the scene later in the studio, planning the composition through the viewfinder. As is often the case, the photograph has slightly dulled the colours, and the foreground is out of focus because it was too close to the camera (see page 28), but it provides adequate reference for all the features to be included. As in all his paintings, the artist has heightened the colours, taking the key from the purplish-grey of the baby olive trees, and he has also made compositional changes, the most

obvious being the format chosen for the painting, which is almost square. This has allowed him to slightly exaggerate the curves and to increase the area given to the foreground, making a stronger composition with more emphasis on pattern and a greater sense of space.

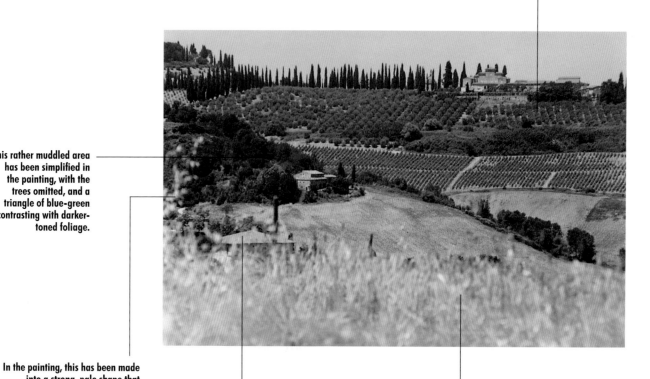

The colour and tonal contrasts are both heightened in the painting, and the rows of small trees given a more pronounced curve.

This rather muddled area has been simplified in the painting, with the trees omitted, and a triangle of blue-green contrasting with darker-toned foliage.

In the painting, this has been made into a strong, pale shape that stands out against the dark trees, taking the viewer's eye up from foreground to middleground.

The buildings and chimneys are omitted in the painting, as they are not helpful to the composition.

The foreground is given more space than in the photograph, with a suggestion of detail and positive, warm colours that bring the area forward in space.

1 *The artist achieves his rich, vibrant colours by building them up in a series of layers, so that each new colour is modified by the one beneath. He begins with a deep purple underpainting, which will influence the colours laid on top. He is working on heavy watercolour paper.*

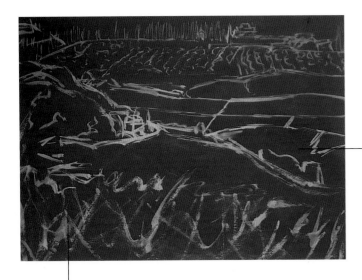

The ground is prepared with a mixture of violet and blue paint and acrylic modelling paste. The paste ensures a matt surface and a degree of texture.

An un-mixed tube colour, light blue-violet, is used for the sky. This will be overlaid with other colours later.

A brush drawing in dilute yellow ochre maps out the main lines of the composition. The colour scheme is based on the yellow/purple complementary contrast.

2 *The next stage is to establish the light tones in the foreground, middleground and sky. The artist uses a brand of acrylic paint that provides both transparent and opaque pigments, and he lays opaque over transparent and vice versa.*

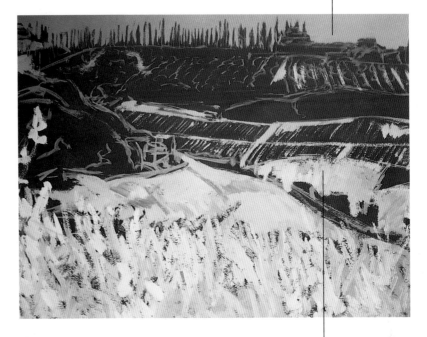

Here you can see the importance of the underpainting. By leaving lines of the deep purple showing between the brushstrokes of green, the artist makes a colour link between this area and the one above.

The field was underpainted in transparent red/brown, and various shades of opaque yellow, mixed with white, are then laid on top.

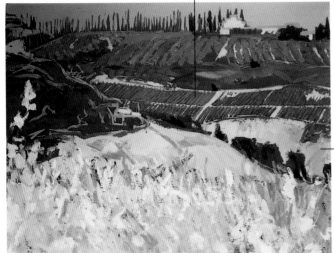

To preserve the unity of colour, the artist uses similar pinks for this field and for the building at the top. This colour will be modified later by overpainting, but the pink will influence later colours.

3 *The contrast between the purple of the baby trees and the yellows of the grasses, fields and patches of soil sets the colour key for the whole painting, so the trees are painted before the greens are brought in.*

4 *The stripes of light soil are painted between the mid-toned greens in the middle field, and then attention is turned to the foreground grasses. Here, brilliant red-oranges and yellows are used to bring the area forward in space. The artist uses a long bristle brush about 13mm (¹/₂in) wide at the tip, which he finds very versatile, as it can produce both fine and broad brushmarks.*

The perspective lines are very important here and in the field below, as they create the illusion of space as well as describing the slope of the hills.

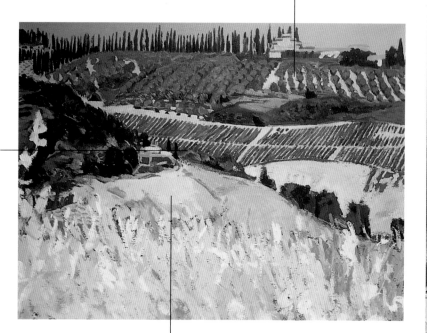

The dark line of trees cutting diagonally across the picture also plays a part in creating space, making a natural boundary between the middleground and the distance.

The colour of the fields has been knocked back slightly by dragging more muted colours over the yellow-pinks. The tones and colours have to be controlled carefully in this area.

The building is given more positive definition. This has an important role in the composition, as the eye is drawn to it and thence travels on and up towards the buildings on the skyline.

5 *As he works, the artist continually assesses one colour and tone against another, making small changes and modifications all over the picture. The main change at this stage is to the sky, to which he gives more brilliance by overlaying the original mauve-blue with a greener blue.*

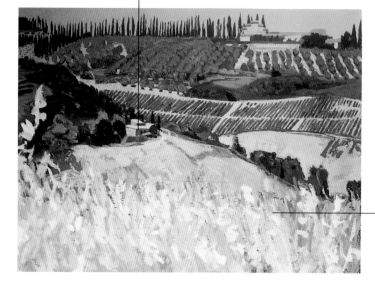

The foreground grasses are worked hand-in-hand with the field behind, with lighter tones brought in to the grasses. Notice how the grasses overlap the dark trees on the right, linking foreground and middleground.

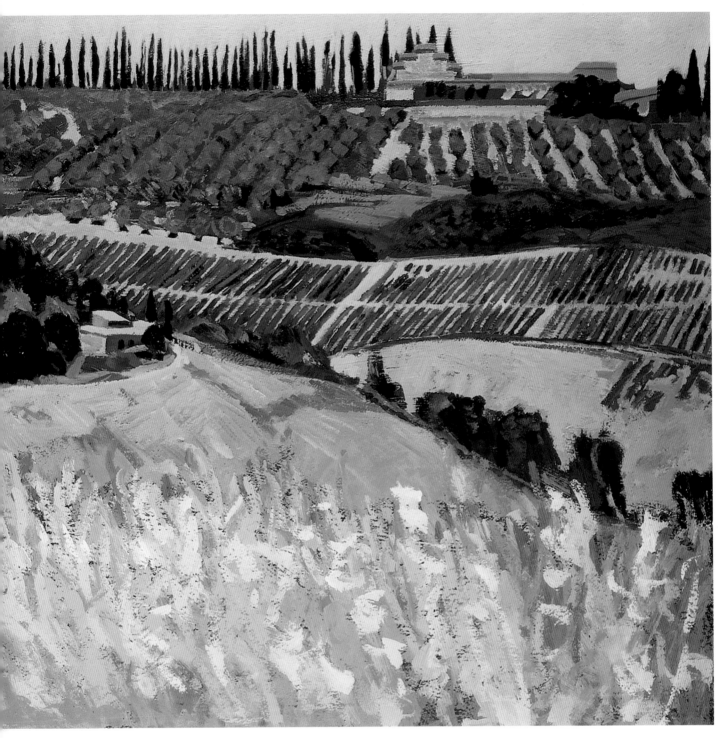

Landscape, Val d'Elsa
David Cuthbert

The main work in the final stages of the painting was to alter the sky again. The overpainting of the sky (see Step 5) resulted in a brilliant, rather cold turquoise hue that did not work well with the other colours, so this was overpainted again with a light violet colour, used thinly and smudged with the fingers to create a soft effect. This veil of colour, through which the turquoise is just visible, gives a lovely glow that can seldom be achieved with flat colour. Apart from this, several details were tidied up, including the central path through the fields, and the area behind the grasses was again knocked back with overlays of a neutral, green-tinged colour, pushing it a little further back in space.

Artists' gallery: *painting landscapes*

The outdoor world offers a vast choice of subject matter, from wide panoramas and the drama of hills and mountains to close-ups of landscape features, such as rocks and trees. In the paintings shown here, the artists exhibit very different interests, and have made many of the important pictorial decisions at the photography stage.

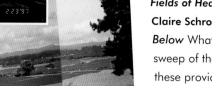

***Fields of Heather,* pastel**
Claire Schroeven Verbiest
Below What appealed to this artist was the long horizontal sweep of the fields, and she took three panning shots. Two of these provided reference for the sketch in which she planned the composition – notice that she has made major changes, stressing the shapes made by the shallow diagonals that intersect the fields.

Eucalyptus IV, **watercolour**
Joan Roche
Above This is one of a series of paintings exploring the textures and patterns of tree bark. A very precise and controlled wet-on-dry watercolour technique has been used, with the paint taken carefully around each light area. The colours in the painting are very different to those in the photo, as are the tonal values: strong lights and darks have been played down to give an overall mid-tone.

Blue Skies, **watercolour**
Sue Kemp
Above The artist was interested as much in the light effects as in the rocks, and she has departed radically from the rather dull colours of the photograph. She has also given more emphasis to the rocks by increasing their height, and has improved the composition by inventing clouds that balance this dominant feature and also give a sense of movement.

Exploiting *landscape textures*

UNDERSTANDING YOUR MEDIUM

Acrylic paints were only introduced in the late 1950s, and even then were neither widely available nor fully developed. Michael Warr has been using them since about 1963, and sees himself as having grown up with the medium. He also works with egg tempera, and likes to achieve in his acrylic work the same smooth, matt surface, with barely visible brushmarks. He paints landscape more than any other subject, and has a particular interest in the textures of both natural and man-made objects.

Abandoned Cart, acrylic

Below The grain of the canvas shows through the thinly applied paint, helping to suggest the texture of the cart. The photograph, although providing adequate visual reference for both texture and structure, is cluttered in terms of composition, and has been edited down to make a much more powerful statement, with the cart standing alone in a spacious, barren landscape.

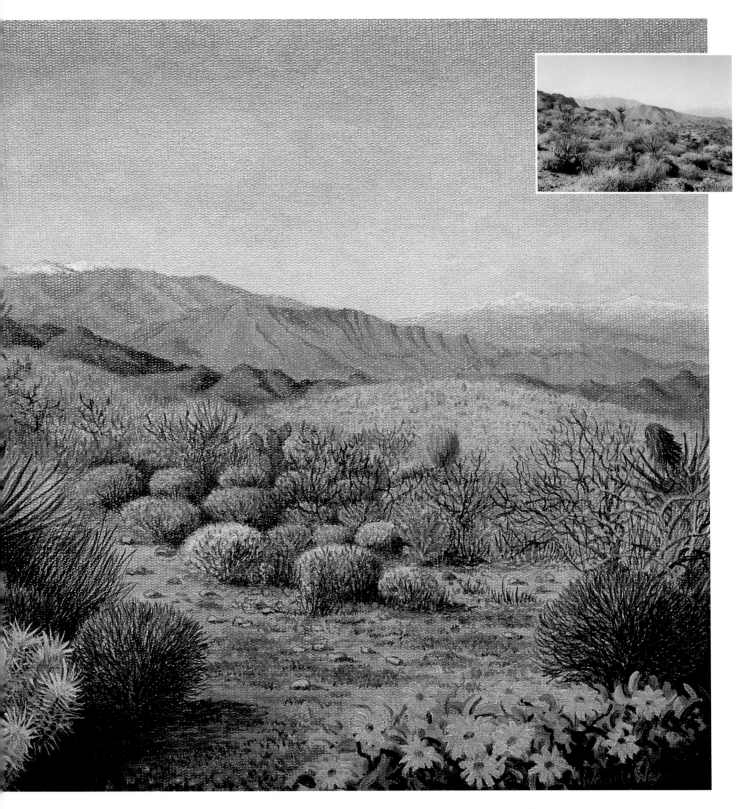

Colourful Desert, acrylic

Above The artist's fascination with textures is very evident in this painting, but colour is also a major factor, and he has imparted a rich glow to the scene by the use of yellows and rich red-browns that contrast with the grey-greens of the cactuses. Unlike the photograph, the painting gives a powerful sense of space and has a strong composition, achieved mainly by bringing in additional foreground elements and stressing the clumps of cactus in the middle distance.

Pfeiffer Beach, California
by *Michael Warr*

- **Working from multiple reference**
- **Featuring texture**
- **Layering colours**

Michael Warr builds up his paintings gradually and methodically, layering thin colours over one another, and because this method is relatively slow, he often works in the studio from photographs rather than painting direct from the subject. For this painting, he has used several photographs, a selection of which is shown below, together with sketches made on the spot.

The driftwood was photographed in close-up, but in case the photo was unclear or badly exposed, a sketch was also made, using watercolour and pen.

This shot provided the basic structure of the composition, but has insufficient foreground interest.

This detailed drawing was made with watercolour pencil, a useful sketching medium as it can produce both tone and line. When damped with q brush, the pencil lines spread out to create a mid-toned wash.

The artist decided to feature this rock, with its cracks and holes, but has altered the colour in the painting.

This provided useful reference for the shapes and forms of the rocks, which have been considerably rearranged in the painting.

1 *The artist is working with acrylic on smooth board. His first step, before drawing, was to knock back the white of the board with a dilute mixture of white and raw sienna. This establishes a warm feeling, setting the key for the overall colour scheme.*

A further layer of colour is laid over the original wash. The paint is used very thinly, diluted with water, and is applied with nylon brushes.

Further layers of paint have been laid over this area, beginning to build up the shapes and forms. The paint looks very much like watercolour at this stage.

The shapes are drawn over the wash with a soft pencil before more colour is added.

Acrylic is relatively transparent when diluted with water, and the blue only partially covers the yellow ground colour.

2 *The sky provides the main contrast to the yellows and golden-browns, and the artist begins to introduce blues before strengthening the colours of the cliffs and pieces of driftwood. He continues to use the paint thinly, ensuring that there is a good basic underpainting.*

The paint is now used slightly more thickly, at about the consistency of gouache paint. The colours are blended together while still wet to create a soft effect.

3 *The sky in the photograph was clear, but the artist wants more interest here, so he indicates a light cloud pattern. He takes care not to overdo this, however, as the sky must not be allowed to compete with the foreground, which is the main subject of the painting.*

The detail in this area will be left until the final stages, but the main tones are indicated with light washes.

The tones of the large central rock are judged carefully against those of the cliff. It must be slightly lighter overall so that it takes its proper position in space.

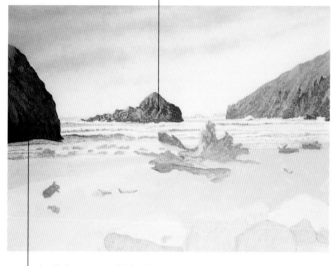

4 *Although acrylic is opaque when used undiluted, and can be worked dark to light, the artist prefers the watercolour technique of working from light to dark in thin or semi-opaque layers. He now begins to bring in the middle and dark tones, working with slightly thicker paint.*

This dark tone is established before further work is done on the driftwood. Here also the paint is used more thickly, with several colours laid over one another.

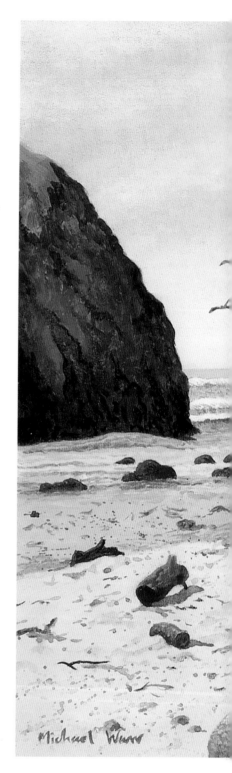

A very small sable brush is used to paint the crests of the waves with pure white. In the shallows, hints of the undercolour are left showing to describe the thin layer of water over the sand.

5 *With the tones and colours of the rock and cliffs now in place, the artist turns his attention to the driftwood, which is the focal point of the painting, and then to the water.*

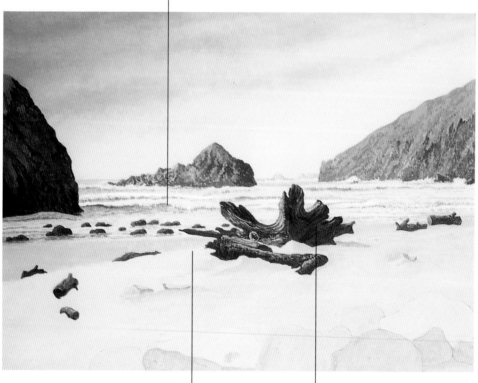

At this stage, paler yellow is laid over the original wash, thinner in places to suggest the slight swell of the beach.

The paint is now used increasingly thickly, with directional brushstrokes building up the forms and textures.

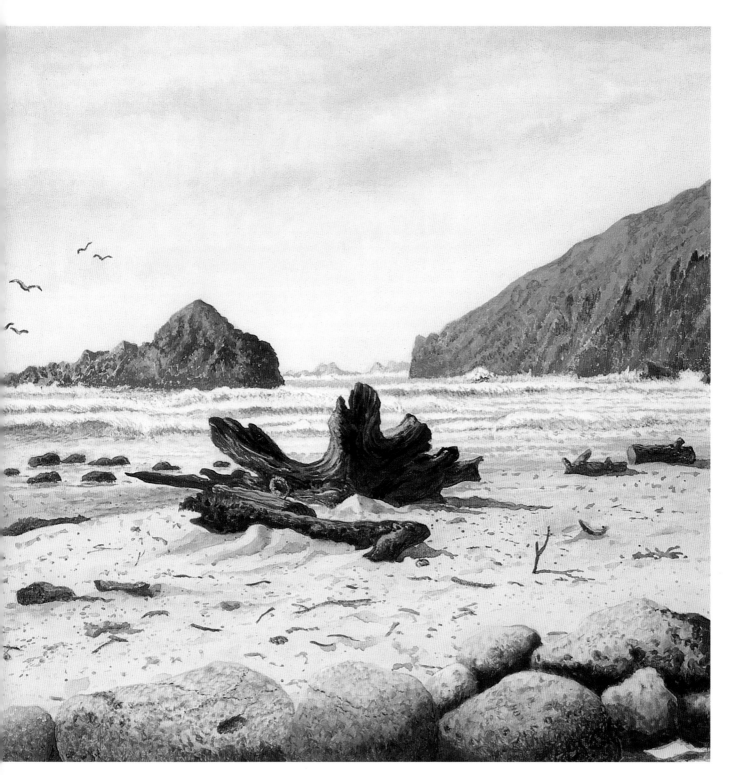

Pfeiffer Beach, California
Michael Warr

The final stages of the painting were to paint the foreground rocks and add some pieces of debris on the beach, together with the long cast shadows that combine with the warm colours to give the painting a rich evening glow. The waves were given more emphasis with darker colours under the white crests, and some seagulls were painted above the rock. This was a last-minute touch, when the artist assessed the picture and decided some extra interest was needed to balance the busy foreground.

Index

Credits

Quarto Publishing plc. would like to acknowledge and thank all the artists who have kindly allowed us to reproduce their work in this book. We would also like to thank in particular those artists who demonstrated for step-by-step photography:
Margaret Glass, Marjorie Collins, Michael Lawes, Peter Welton, Christine Russell, Annie Penney, David Cuthbert and Michael Warr.

Credits